YOU CAN
DRAW
IN 30 DAYS

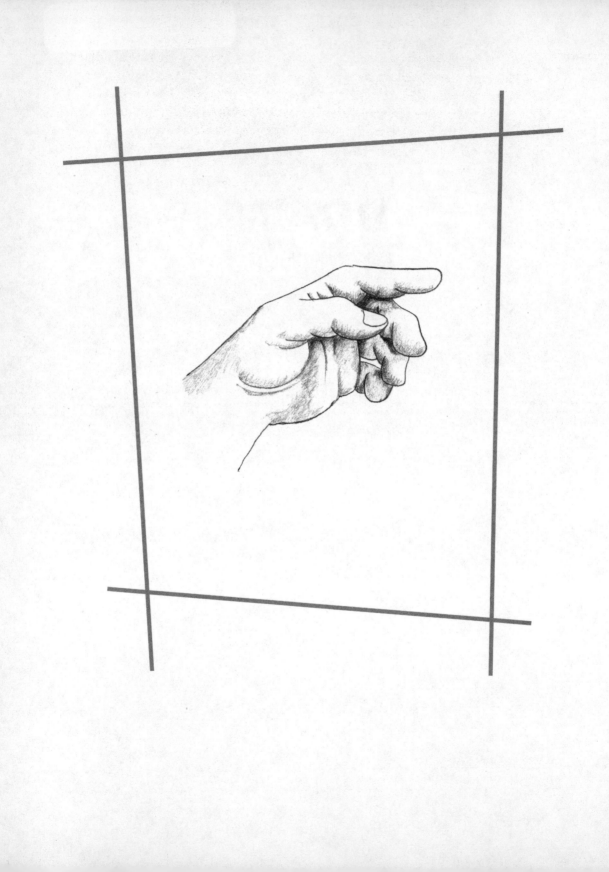

Mark Kistler's

You Can Draw *in* 30 Days

The Fun, Easy Way
to Learn to Draw
in One Month or Less

Go

hachette
BOOKS

New York

Hachette Go, an imprint of Hachette Books
Hachette Book Group
1290 Avenue of the Americas
New York, NY 10104
HachetteGo.com
Facebook.com/HachetteGo
Instagram.com/HachetteGo

Previously published by Da Capo Lifelong: 2017
First Hachette Go edition: 2020

Hachette Books is a division of Hachette Book Group, Inc.
The Hachette Go and Hachette Books name and logos are trademarks of Hachette Book Group, Inc.

The publisher is not responsible for websites (or their content) that are not owned by the publisher.

Set in 11 point Relay Light by the Perseus Books Group

Library of Congress Cataloging-in-Publication Data
Kistler, Mark.
 You can draw in 30 days : the fun, easy way to learn to draw in one month or less /
Mark Kistler.—1st ed.
 p. cm.
 ISBN 978-0-7382-1241-8 (pbk. : alk. paper)
 1. Drawing—Technique. I. Title. II. Title: You can draw in thirty days.

NC730.K57 2011
741.2—dc22

 2010036712

LSC-C

Printing 34, 2021

This book is dedicated to my dear sister Mari

(http://mari-kistler.memory-of.com/About.aspx)

Mari, LOOK! You're in my book just like I promised you!

Contents

Introduction

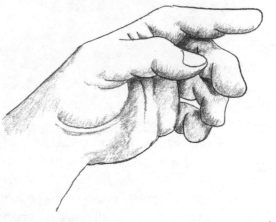

Congratulations! If you've picked up this book, you are exploring the possibility that perhaps, just maybe, you really could learn to draw.

Guess what? You're right! Even if you have little or no previous drawing experience, and even if you don't believe you have natural talent, if you can find a few pencils and twenty minutes a day for thirty days, you can learn to draw amazing pictures. Yes, you have found the right teacher. And yes, you have found the right book.

Welcome to my world of creative possibilities. You will learn to create realistic renderings of everything from photos to landscapes from the world you see around you and to draw three-dimensional pictures entirely from your imagination. I know this is a big claim filled with enormous promise. I'm aware that you may be skeptical and wondering how I can make such a statement. The simplest way for me to qualify my teaching confidence is to share with you my past student success stories.

Drawing as a Learned Skill

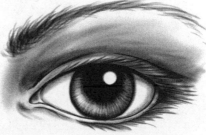

During the last thirty years, I've taught millions of people how to draw during my extensive travels around the country and through my television shows, websites, and videos. Many children have grown up watching my drawing lessons on public television and have gone on to pursue careers in illustration, animation, fashion design,

design engineering, and architecture. I have alumni students who have helped design the International Space Station, NASA's Space Shuttle, and Mars Exploration Rovers and others who have worked on animation megafilm projects such as *Shrek*, *Madagascar*, *Flushed Away*, *The Incredibles*, *Happy Feet*, and *A Bug's Life*.

But here's a secret—learning is learning and drawing is drawing, no matter how old you are. My techniques work for adults just as well as they work for kids—I know this, because I've taught thousands of adults as well. In this book, I will introduce sophisticated concepts and complex drawing theories in a simple, easy-to-follow way, but because I'm a kid at heart, I will not cut back on any of the fun that I believe drawing must be.

By Kimberly McMichael

I am a cartoon illustrator by trade, but these lessons will give you the basic skill set that will enable you to draw three-dimensionally in any style (realistic drawings, photograph studies, portraits) or medium (oil paints, watercolors, pastels).

I will teach you how to draw using the same step-by-step, follow-along method that has proven successful for all my students. I will focus almost exclusively on what I call the "Nine Fundamental Laws of Drawing," beginning with basic shapes, shading, and positioning, all the way through more advanced perspective, copying from photos, and drawing from life. These basic concepts, discovered and refined during the Italian Renaissance, have enabled artists to create three-dimensional renderings for more than five hundred years. I will teach you these basics, one key term at a time, one step at a time, one line at a time. I believe that anyone can learn how to draw; it is a learnable skill like reading or writing.

The Nine Fundamental Laws of Drawing create the illusion of depth. They are as follows:

1. **Foreshortening:** Distort an object to create the illusion that one part of it is closer to your eye.
2. **Placement:** Place an object lower on the surface of a picture to make it appear closer to your eye.
3. **Size:** Draw an object larger to make it appear closer to your eye.
4. **Overlapping:** Draw an object in front of another object to create the visual illusion that it is closer to your eye.
5. **Shading:** Draw darkness on an object opposite the positioned light source to create the illusion of depth.

6. **Shadow:** Draw darkness on the ground next to the object, opposite the positioned light source, to create the illusion of depth.
7. **Contour lines:** Draw curving lines wrapping around the shape of a round object to give it volume and depth.
8. **Horizon line:** Draw a horizontal reference line to create the illusion that objects in the picture are varying distances from your eye.
9. **Density:** Create the illusion of distance by drawing objects lighter and with less detail.

It is impossible to draw a three-dimensional image without applying one or more of these fundamental laws. These nine tools are foundational elements, never changing, always applicable, and totally transferable.

In addition to the Nine Fundamental Laws of Drawing, there are three principles to keep in mind: attitude, bonus details, and constant practice. I like to call them the "ABCs of Successful Drawing."

1. **A**ttitude: Nourishing your "I can do this" positive attitude is a crucial part of learning any new skill.
2. **B**onus details: Add your own unique ideas and observations to your drawing to make it truly your own expression.
3. **C**onstant practice: Repeated daily application of any new learned skill is absolutely necessary for successful mastery of the skill.

Without exercising these three principles, you will not be able to grow as an artist. Each one is essential to your creative development.

In this book, we'll also focus on how the Nine Laws are applied to the four basic "molecules," or building blocks, of three-dimensional drawing: the sphere, the cube, the cylinder, and the cone.

ANCIENT "ELEMENTS" of DRAWING...

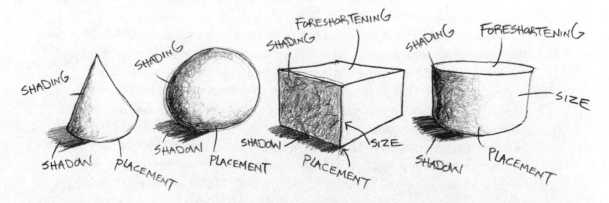

You *Can* Learn to Draw

With each lesson, I will be introducing new information, terms, and techniques, but I also will be repeating definitions and applications you've previously learned. In fact, I'll be repeating myself so often that you will undoubtedly start to think, "This guy sure repeats himself a lot!" But I have found that repetition, review, and practice produce success—and they also keep you from having to jump out of your lesson to hunt for the original explanation.

The biggest criticism I have received in thirty years of teaching is, "You are teaching students to copy exactly what you are drawing! Where's the originality? Where's the creativity in that?" I've heard this comment countless times and always from a critic who has never drawn a lesson from my books, classes, website, or public television series. My response to this is always the same: "Have you ever tried to draw a lesson with me?" "No." "Here, sit down with this pencil and this 'rose' lesson, right here at this table, for twenty minutes. In twenty minutes, after you complete this lesson, I'll answer that question for you."

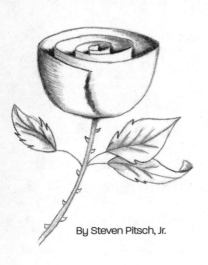

By Steven Pitsch, Jr.

Most critics walk away, but a few adventurous souls actually do sit down and draw this "rose" lesson. For these idea explorers, the possibility lightbulb could almost be seen shining over their heads as they leaned over the table, drawing the rose.

The point I'm trying to make here is that to learn how to draw, a person first has to draw. A student has to be inspired to actually pick up a pencil and make lines on a blank sheet of paper. Many people I meet are truly terrified of this idea. That blank sheet of paper is an unsolvable problem that only talented artists can master, they think. But the truth is that learning how to draw with the Nine Fundamental Laws of Drawing will give you a solid foundation of confidence, which will enable you to enjoy drawing as a personal form of creative expression.

We all, every single one of us, loved to draw when we were toddlers. We drew on everything! We drew on paper, on tables, on windows, in pudding, in peanut butter . . . everything. All of us were born with this amazing gift of confidence and creativity. Every picture that we drew was a masterpiece in our minds. The castle with the flying dragon was a perfect illustration of medieval action. Our parents strengthened this confidence with encouraging comments like, "So, little Marky, tell me about this wonderful drawing!" Somewhere along the way, sometime between the third and sixth grade, a few people began to say to us, "That doesn't look like a castle with a dragon flying over it! It looks like a pile of poop (or some other unflat-

tering comment)." Slowly over time, enough negative comments eroded our amazing artistic confidence to the point that we began to believe that we just didn't have the "talent" to draw or paint or create. We moved on to other interests, believing for decades that we couldn't draw.

So here we are together now with this book. I will prove that you *can* learn how to draw by:

1. Inspiring you to pick up a pencil again.
2. Sharing with you immediate success in drawing simple three-dimensional objects that actually look like the three-dimensional objects that you set out to draw.
3. Rekindling that amazing artistic self-confidence that has been dormant in you for decades by slowly, incrementally, introducing you to easily digestible bits of the "science" behind drawing as you experience one wonderful successful lesson after another.

Now, back to the critic's question, "Where is the creativity in copying exactly what I draw?" I sometimes answer, "Did you copy and trace letters of the alphabet in first grade?" Of course, we all did. That is how we learned how to confidently write our letters. We then learned how to write words and put them together to make sentences: "See Mark run!" Then we put the sentences together to make paragraphs, and finally we put the paragraphs together to create stories. It's simply the logical progression of learning a communication skill. I take this same progression in teaching the visual communication skill of drawing. You never hear anyone say that they can't write a letter, a recipe, or a "Meet me at Starbucks" note because they just do not have the "talent" to write. This would be silly. We all know we do not need talent to learn how to write as a communication skill.

By Steven Pitsch, Jr.

I apply this same logic to learning how to draw. This book is not about learning how to draw a museum-quality masterpiece or drawing animated sequences worthy of a *Shrek* sequel. But this book will give you a foundation for drawing that image in your head or that photograph you have always wanted to sketch, for drawing those driving directions for your friend, for drawing that icon or graph on that office report, or for drawing that image on the dry

erase board in a meeting without the obligatory, self-deprecating "Sorry this looks so bad. I never could draw."

Let's follow your historical path a bit longer. You were in a high school or college art class, and the teacher put a pile of objects on the "still life" table and said, "Draw that. You have thirty minutes." That's it! No instruction, no road map, except perhaps a few vague comments about "seeing" the negative spaces surrounding the pile of objects. So you gave it a valiant effort, you drew your heart out, and despite the art teacher's wonderful supportive encouraging comments, "Great effort! Good job! We'll do this one hundred more times and you'll nail it!" you saw the result of your effort glaring at you from the paper: It looked like a pile of scribbles.

I remember annoying my college art teacher to no end during still life drawing exercises. I'd constantly chatter to neighbors on both sides of my easel. "You know," I'd whisper, "if you try drawing that apple lower on the paper, and the banana higher on the paper, you would make the apple look closer, just like it does on the still life table."

The prevailing methods of teaching Drawing 101 force the student to figure out how to draw through a long process of trial and error. This method dates back to 1938 and an extraordinary book by Kimon Nicolaides, *The Natural Way to Draw* (a book you should add to your library!). In it he states " . . . the sooner you make your first 5,000 mistakes, the sooner you will learn how to correct them." This approach just doesn't make sense to me. With all due respect to this book as a profound work, a classic in teaching art students how to draw . . . but, Why? I ask. Why discourage students with such a daunting task of failing 5,000 times when I can show them in just twenty minutes how to succeed? Why not build up their skill, confidence, and interest all at the same time?

The thirty-day method in this book will increase your success, inspire your practice, build your confidence, and nourish your interest in drawing for life.

I urge you to take a small creative risk with me. Give me thirty days, and I'll give you the keys to unlock all the drawing talent already within you.

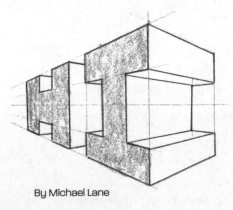

By Michael Lane

What You'll Need

1. This book.
2. A spiral-bound sketchbook or blank journal with at least fifty blank pages.
3. A pencil (for now just grab any pencil within reach).
4. A "drawing bag" to hold your sketchbook and pencils (anything will do: a recyclable grocery cloth bag, a book backpack, a book bag with handles. You want to make it very easy to quickly grab your drawing bag whenever you have a spare couple of minutes to scratch out a few drawings).
5. A day planner or calendar (probably the most important item in this check-list). You will need to strategically and methodically carve out a small twenty-minute chunk of time each day to draw with me. If you plan now, today, you will be able to follow through with our thirty-day plan.

Step One

Get out your planner and a pencil—let's schedule some drawing time for just this first week. I know your days are intensely busy, so we'll get creative. Imagine that the pencil in your hand is a steel chisel and you're going to carve out one twenty-minute chunk each day for seven days. If this is too difficult, try chiseling out two chunks, ten minutes each. Ideally, these time chunks will be at your desk, your kitchen table, or some fairly quiet table space. My goal is to get you to commit to one week with me. I know that once you accomplish the first seven days (seven lessons), you'll be totally hooked. Immediate success is a powerful motivator. If you can draw daily for a week, you'll successfully finish this book in a month. However, it is perfectly acceptable to take a more leisurely approach and focus on only a few lessons a week, spending much more time on the lesson steps and the fun bonus challenges I introduce at the end of each lesson. I've had a few students do amazing work by completing just one lesson a week. It's totally up to you. The key is this: Just don't give up.

Step Two

Start drawing! Sit down at a table with your drawing bag. Take a nice deep breath, smile (this is really going to be fun), open your bag, and begin.

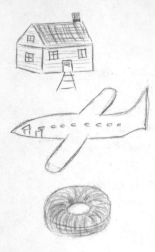

"Before" sketches
by Michele Proos

"After" sketches by Michele Proos

Test Yourself

Okay, enough about my teaching philosophy and methodology; let's put the pencil to the paper and start drawing.

Let's begin with a little pretest so that you will have a reference point later on.

I want you to draw a few images for me. Consider these "warm-up" scribbles. Relax. You are the only person who ever has to see these. I want you to draw the images that follow in order to give yourself a baseline skill assessment of where you are now, as compared to where you will be in thirty days. Even if you are totally tempted to skip this part (because no one will ever know!), humor me, humor yourself, and draw these images. In thirty days you will be glad you did.

Open your sketchbook. At the top of the first page write "Day 1 of 30, Introduction: The pretest," today's date, the time, and your location. (Repeat this information, with the appropriate lesson number and title, at the beginning of each of the lessons.)

Now spend two minutes drawing a house. Just from your imagination, don't look at any pictures. Next, spend two minutes drawing an airplane. And finally, spend two minutes drawing a bagel.

I trust you are not completely stressed from that. Kind of fun? I want you to keep these warm-up drawings in your sketchbook. You will be able to compare these warm-up drawings with the advanced lessons later in this book. You are going to be amazed with your phenomenal improvement!

Here you'll find Michele Proos's warm-up page from her sketchbook. Michele always wanted to learn how to draw but never had. She signed her children up for one of my family art workshops in Portage, Michigan. Like most parents, she sat in with her children and participated. Michele has graciously agreed to participate in this thirty-lesson course and share her sketchbook pages with you. Keep in mind that she came to my first workshop convinced she couldn't draw a straight line, and she believed that she had "no artistic talent whatsoever." She sat with her children in the class, but she was very reluctant to par-

"Before" sketches by Tracy Powers

"After" sketch by Tracy Powers

"Before" sketches by Michael Lane

"After" sketch by Michael Lane

ticipate. As soon as I met her, I knew she was the perfect person to represent the population of adult readers that I am hoping to reach with this book: the person who thinks she can't draw and thinks she is totally void of talent.

I explained this "You Can Draw in 30 Days!" book project to her and invited her to be my laboratory student. In fact, as I was explaining this new book project to her, other parents in the workshop overheard, and all wanted to participate! A very enthusiastic seventy-two-year-old grandfather was so impressed with what he

learned in just one forty-five-minute workshop with me that he also volunteered to be a laboratory student. I'll be sharing many of these parents' and grandparents' sketchbook pages along with those of some of my other students as we progress together through the thirty days of lessons. My students are from all over the United States, from Michigan to New Mexico. They're all ages, and their occupations range from IT consultants and professional hairdressers to business owners and college deans. And they're proof that no matter what the background or experience, anyone can learn to draw.

This amazing jump in skill level is the norm, not the exception. You can and you will experience similar results. Michele Proos also drew the illustrations I featured on the preceding pages of the eye, the rose, and the human face.

Indulge me a bit longer here: Being a teacher, I'm compelled to flaunt my students' work. I just love to share my students' enormous leaps of drawing skill and creative confidence.

Are you inspired? Are you excited? Let's begin.

LESSON 1

THE SPHERE

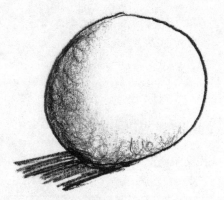

*L*earning how to draw is in large part learning how to control light in your picture. In this lesson you will learn how to identify where your light source is and where to shade objects in your drawing. Let's draw a three-dimensional sphere.

1. Turn to the next page in your sketchbook. Draw a circle. Don't stress if your circle looks like an egg or a squished blob. Just put the pencil to the paper, and draw a circular shape. If you want, trace the bottom of your coffee cup, or dig in your pocket for a coin to trace.

RELAX, NO STRESS...
DRAW LOOSE
AND SKETCHY.

2. Determine where you want your light source. *Wait, what's a light source? How do you determine where a light source is? I'm feeling overwhelmed already! Ahhhh!* Don't throw your sketchbook across the room just yet. Read on.

To draw a three-dimensional picture, you need to figure out what direction the light is coming from and how it is hitting your object. Then you apply shading (a shadow) opposite that light source. Check this out: Hold your pencil about an inch above your paper, and notice the shadow it makes. If the light in the room is directly above the pencil, for example, the shadow will be directly below your pencil. But if the light is coming at the pencil from an angle, the shadow on the paper will extend out away from the light. It's pretty much common sense, but being aware of where

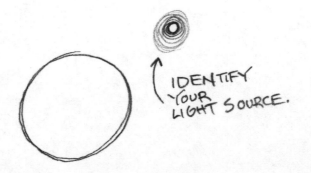

IDENTIFY
YOUR
LIGHT SOURCE.

the light is coming from, and going to, is an amazingly effective way of bringing your drawings to life. Play around with your pencil and the shadow it makes for a few minutes, moving it around and up and down. Place one end of the pencil directly on your paper, and note the way the shadow begins attached to the pencil and is thinner and darker than the shadow cast when the pencil is in the air. The shadow is called (three guesses) a *cast shadow*.

For the purpose of our lesson, position a single light source above and to the right of your sphere like I have drawn here. Go ahead and draw a little swirly sun right on your sketchbook page.

3. Just like the cast shadow your pencil created on the table, the sphere we are drawing will cast a shadow onto the ground surface next to it. Cast shadows are fantastic visual anchors that help secure your objects to the ground surface in your picture. Look how I have drawn my cast shadow off to the side of the sphere below. Now draw a cast shadow on your sphere opposite your light source position on your sketchbook page. It does not matter if you think it looks sloppy, messy, or scribbly. These drawings are for skill practice and your eyes only.

Just remember these two important points: Position your light source, and cast a shadow onto the ground next to the object and opposite the light source.

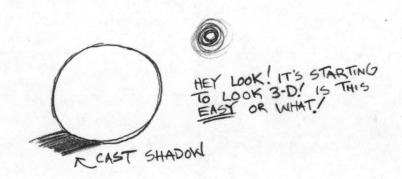

HEY LOOK! IT'S STARTING TO LOOK 3-D! IS THIS EASY OR WHAT!

↖ CAST SHADOW

4. Scribble shading on the circle opposite the light source. It's okay to go outside the lines—don't worry about being perfect.

Notice how I have scribbled a bit darker on the edge farthest from the light source and how I have scribbled lighter as the shading curves up toward the light source. This is called *blended shading*. It is an awesome tool to learn to really create the "pop-out" illusion of three-dimensional drawing.

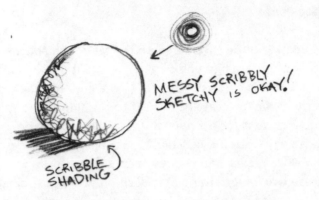

MESSY SCRIBBLY SKETCHY IS OKAY!

SCRIBBLE SHADING

5. Use your finger to smudge-blend your shading like I have done here. Check this out: Your finger is actually an art tool similar to a paintbrush! Cool effect, isn't it?

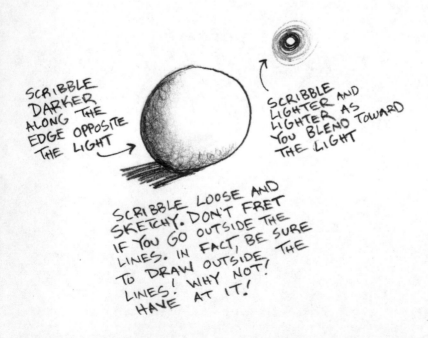

SCRIBBLE DARKER ALONG THE EDGE OPPOSITE THE LIGHT

SCRIBBLE LIGHTER AND LIGHTER AS YOU BLEND TOWARD THE LIGHT

SCRIBBLE LOOSE AND SKETCHY. DON'T FRET IF YOU GO OUTSIDE THE LINES. IN FACT, BE SURE TO DRAW OUTSIDE THE LINES! WHY NOT! HAVE AT IT!

Voilà! Congratulations! You have turned a scribbled circle into a three-dimensional sphere. Is this easy or what?

Here's what we've learned so far:

1. Draw the object.
2. Identify the light source.
3. Shade.

Easy as pie.

Lesson 1: Bonus Challenge

One important goal of this book is to teach you how to apply these lessons to drawings of "real-world" objects. In future lessons we will be applying the concepts you have learned in drawing this three-dimensional sphere to drawing fun interesting objects you see in the world around you. Whether you want to draw a colorful bowl of fruit on a table or a sketch of a family member in real life or from a photograph, you will have the tools to do it.

Let's start with drawing a piece of fruit, an apple. In following lessons we will tackle more challenging objects, such as buildings and people.

Take a look at this photograph of an apple with the light source low and on the right.

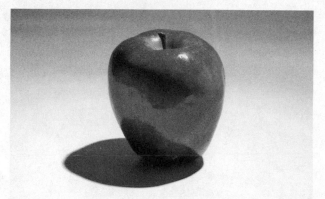

Photo by Jonathan Little

Take a look at these drawings from folks just like you!

Student examples

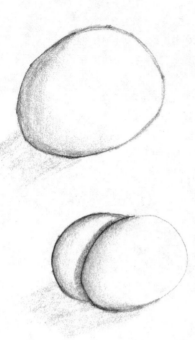

By Tracy Powers

By Kimberly McMichael

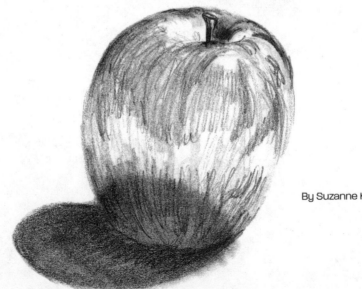

By Suzanne Kozloski

OVERLAPPING SPHERES

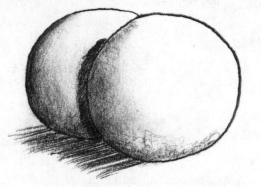

*Y*ou have completed Lesson 1! Way to go! Now, let's use that sphere skill of yours to draw globes all over the place.

1. Space permitting, continue on the same sketchbook page. Draw a circle.

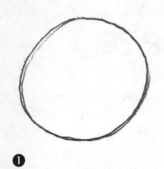

❶

2. Draw a second sphere behind the first one. How? As you draw this second sphere, you will be using three new drawing laws. Three at once!! Have no fear: We will take them one concept at a time, and it will take far longer to read about them than to use them. Take a look at my example below. I have drawn the second sphere a bit smaller than the first sphere, a bit higher up on the paper, and tucked behind the first sphere. In doing this, I've used three drawing laws: size, placement, and overlapping. Go ahead and write these notes in your sketchbook.

Size = Draw objects larger to make them look closer; draw them smaller to make them look farther away.

Placement = Draw objects lower on the surface of the paper to make them look closer; draw them higher up on the paper to make them look farther away.

Overlapping = Draw objects in front of or partially blocking the view of other objects to make them look closer; draw them tucked behind other objects to make them look farther away.

Go ahead and draw the second sphere smaller, higher, and behind the first one like my sketch below.

↓OVERLAPPING

↑
MOVE THIS ONE HIGHER UP, JUST A BIT. THIS IS PLACEMENT.

❷

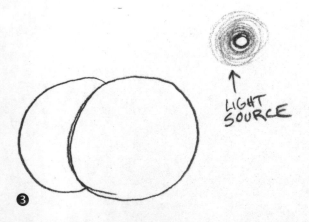

↑
LIGHT SOURCE

❸

3. Determine where your imaginary light source will be positioned. This is probably the most important step in drawing realistically. Without a determined light source position, your drawing will not have consistent shading. Without consistent shading, your drawing will not pop out and look three-dimensional.

4. Keeping in mind the position of your light source, draw a cast shadow. Remember that it goes off to the side, as if it is on the ground, in the direction opposite the light. You do not need a ruler to determine the exact mathematical angle. Just eyeball it for now. As I said earlier, a good solid cast shadow will anchor your drawing to the surface of your paper.

Remember that if at any time you get a bit confused by my text explanation, simply look at my sketch example and copy what I have done. Be patient—all this information will be repeated throughout.

5. To separate objects in your drawing, draw a dark defining shadow in between the two spheres (I call this a nook and cranny shadow). This will help identify the depth between the two objects. Notice how I defined the dark nook and cranny shadow on the farthest sphere. Nook and cranny shadows are always applied under and behind near objects. For example, clasp your hands together on the table in front of you. Take a look at the tiny very dark nook and cranny shadows that define the edges of each finger and knuckle. In your sketchbook write, "Nook and cranny shadows: Separate, define, and identify objects in a drawing."

6. Hold your pencil loosely, and scribble the first layer of shading on both spheres. Shade the surfaces opposite your light source. When I shade, I make several passes over my drawing. This is our first "rough" shading pass. You'll notice that my shading lines below are all lined up away from the sun, but your shading lines do not have to be lined up. Just scribble in the dark area any way you want as long as it is opposite your light source.

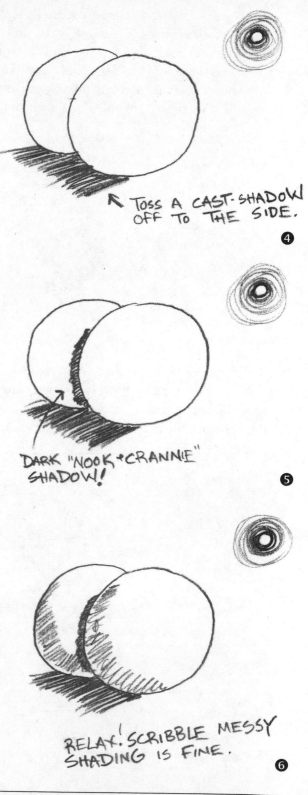

TOSS A CAST·SHADOW OFF TO THE SIDE.

❹

DARK "NOOK·CRANNIE" SHADOW!

❺

RELAX! SCRIBBLE MESSY SHADING IS FINE.

❻

7. Make a second darker, more focused shading pass over the spheres. Detail in the very dark edges, and let your scribbles get lighter and lighter as you move slowly toward your established light source. Look at my sketch below, and notice where I have pointed to the brightest spot on the near sphere. I call this the "hot spot." The hot spot is the area on an object that gets hit with the most direct and brightest light. Determining where the hot spot is in a drawing is very important when you are applying the shading.

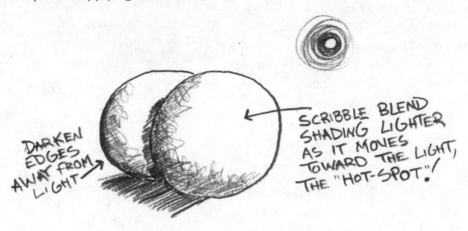

DARKEN EDGES AWAY FROM LIGHT

SCRIBBLE BLEND SHADING LIGHTER AS IT MOVES TOWARD THE LIGHT, THE "HOT-SPOT"!

8. Go ahead and make several more scribbles (blending shading passes) over these two spheres. Now for the fun part! Using your finger, carefully blend the shading from dark to light, trying to keep the hot spot crisp white. Don't worry if you smudge the shading outside the lines or into the hot spot. If you feel like it, use your eraser to clean the excess lines and smudges.

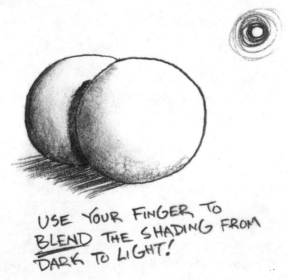

USE YOUR FINGER TO BLEND THE SHADING FROM DARK TO LIGHT!

Awesome job! Look at your beautiful three-dimensional rendering! A masterpiece suitable for any in-home refrigerator art gallery. You can be proud to display this great drawing on your

fridge, right next to your kids' work. If you don't have kids, put this drawing up on your fridge anyway. You will enjoy seeing it with each trip to the kitchen, not to mention the oohs and ahs you will get from your friends!

Take a look at a parent student of mine, Suzanne Kozloski's Lesson 1 sketchbook page.

Now, take a look at how Suzanne Kozloski applied this lesson to drawings from real life.

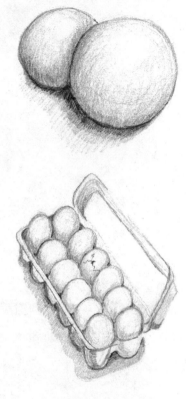

By Suzanne Kozloski

Here is my sketchbook page as I created Lesson 2.

Lesson 2: Bonus Challenge

Now that you have conquered drawing spheres, try placing two tennis balls on the table in front of you, overlapping. Draw what you see. Make sure to notice the objects' placement, shadows, and shading.

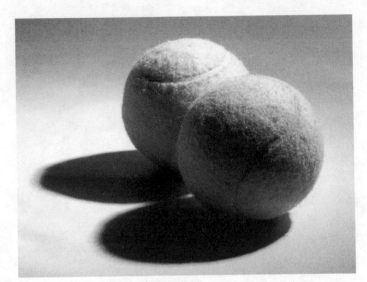

Photo by Jonathan Little

Student examples

Here is Suzanne Kozloski's drawing of this bonus challenge.

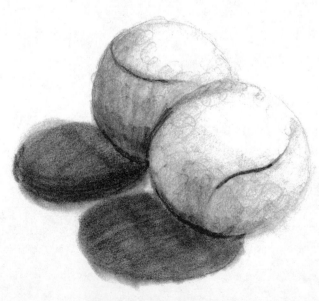

ADVANCED-LEVEL SPHERES

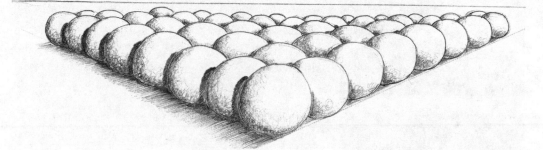

*Y*ou're getting into this now, eh? Just think, this is only the third lesson! Imagine how much fun you'll be having by the thirtieth lesson! Do you want to push the lesson envelope? This next drawing will take you a bit of time, definitely a full twenty minutes, but if you have the time, you could easily spend an hour or more.

Before you tackle this next challenge, I'm going to suggest that you purchase a few really cool drawing tools. Notice how I waited until now to bring these additional costs. This is my sly way of getting some great successes under your belt before inundating you with a shopping list of additional drawing supplies. These supplies are totally optional; you can continue just fine with any regular pencil, any scratch piece of paper, and your finger as your blended shading tool.

Suggested Products

Artist's pencil-blending Stomp (size #3). Stomps are amazing tools you can use (instead of your finger) to blend your shading. These are awesome fun! You can find these in art supply stores. To actually see me using this stomp in a video tutorial, go to my website, www.markkistler.com, and click on "Online Video Lessons."

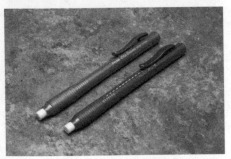

Pentel Clic Eraser. These are very easy to find at your local office supply store or online. These are great eraser tools. They look and act like a mechanical pencil; just click the eraser to extend it for use.

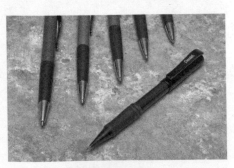

0.7 mm Pentel mechanical pencil with HB lead. There are hundreds of mechanical pencils on the market, and I've tried most of them. This 0.7 mm Pentel is by far my favorite drawing tool. It's easy to handle, adjust the lead length, and draw with. It just "feels" very comfortable to me. Experiment with many brands and types of pencils to determine which ones "feel" right for you.

Photos by Jonathan Little

You see? With just a few additional items in your drawing bag, you have raised your lesson enjoyment level exponentially. Enough about products and tools. Let's get back to producing. Put in your music earbuds and settle in. . . . Let's draw.

1. Look at the drawing at the beginning of the chapter. Looks fun, eh? Looks complicated? Looks difficult? Naw! It's easy when drawn one circle at a time. It's like building a Lego tower, one bumpy little brick at a time. Start with your first circle.

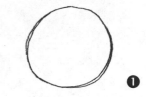

❶

2. Draw another circle behind the first. Push it up a bit (placement). Tuck it behind the first (overlapping). Draw it a bit smaller (size). Yes, you've done this already. This redundancy is very important and intentionally built into the thirty-lesson plan strategy.

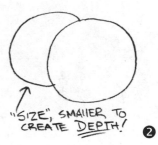

"SIZE", SMALLER TO CREATE DEPTH!

❷

3. Draw the next circle over to the right behind the first one, push it up, tuck it behind, and draw it a bit smaller than the first circle.

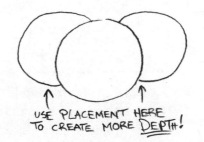

USE PLACEMENT HERE TO CREATE MORE DEPTH!

❸

4. Onward into the third row of spheres. You'll notice this row is definitely getting smaller and much higher on the page as you move away from the front sphere.

When you draw objects smaller to create the illusion that they are deeper in your picture, you are successfully using the fundamental drawing law of size. As you draw this next row of spheres, you need to draw them a bit smaller than the row in front. Size is a powerful tool to create depth.

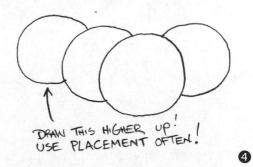

DRAW THIS HIGHER UP! USE PLACEMENT OFTEN!

❹

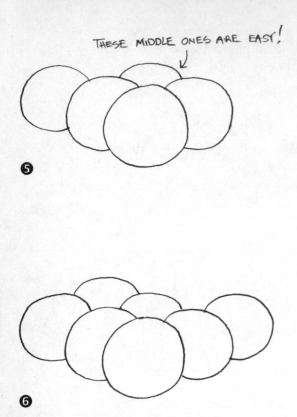

THESE MIDDLE ONES ARE EASY!

5

6

5. Fill in the far gap with a peeking over-the-top sphere. Remember that smaller equals deeper. This is also a great example of the potency of overlapping. By drawing a simple curved line "peeking" from behind, you effectively create a three-dimensional illusion, and you haven't even begun to add shadows, shading, or blending. Overlapping is an awesome, powerful tool to understand. Yet with great power comes great responsibility. . . . Oops, wait, wrong book. I started channeling Marvel Comics for a moment.

6. Complete the third row with the end sphere smaller, higher, and behind. Are you beginning to notice a recurring mantra here? Much of learning how to draw in 3-D is in repetition and practice. I trust you are finding this repetition of drawing spheres to be rewarding, fun, and relaxing. (I'm enjoying drawing these lesson steps even though I've drawn each step perhaps 5,000 times in classrooms during the last thirty years!) Practice can be tedious, but if you can push through, you'll soon delight in the results.

7. Draw the fourth and fifth row of spheres. Pushing each row deeper into your picture with size, placement, and overlapping. We haven't even begun to shade the drawing, and yet it is already starting to pop off the paper in 3-D.

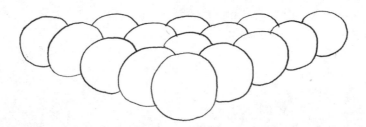

8. Go ahead, go crazy, go wild—draw rows six and seven really receding into the depths of your sketch page. Size really kicks in on these distant rows. You can definitely see the size difference between the front sphere and the back row. Even though the spheres are all the same size in our imagination, we have created the successful illusion that they are receding far away into the sunset.

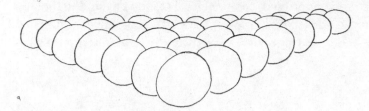

9. I was shooting for twenty rows of spheres, really trying to impress you. However, I lost sight of the spheres at row nine. What a great visual treat. This mob of spheres looks very three-dimensional, and we haven't even determined the light source yet. You can see how powerful these concepts are: Size, placement, and overlapping create effective depth all on their own.

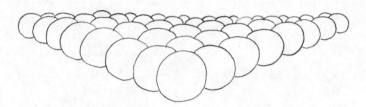

10. Finally, we get to determine the position of our light source. For consistency we will keep the light positioned in the top right. You can mess around with this light position on your own. Try experimenting with this mob of spheres with the light source positioned directly above or over in the top left. If you want to try something really challenging, position the light source from within the sphere mob, making one of the middle orbs glowing hot bright. We will get into moving the light source position around in later lessons. Go ahead and toss some cast shadows off to the left, on the ground, opposite your light source position. Now, draw the horizontal background reference line; this is called the "horizon line." The horizon line will help you create the illusion of depth in your drawing.

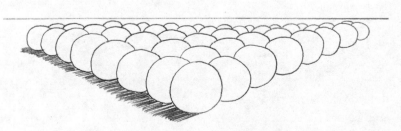

11. My favorite step has arrived, the nook and cranny phase. Push hard on your pencil, and darken the nooks and crannies. Notice the immediate "punch-out" visual effect. Wham—nook and cranny shadows work their wonderful magic once again.

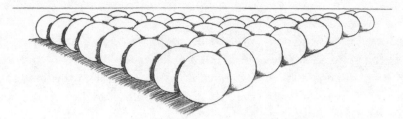

12. Continue your shading process with a first pass over all the objects, scribbling the shading lightly over all opposite edges away from the light source.

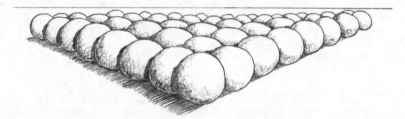

13. Make several more scribble shading passes. With each consecutive pass, darken the edges farthest away from your light source while scribbling lighter and fainter as you move toward the light source. Blend the shading with your finger. Carefully smudge the dark shaded areas up toward the hot spots, lighter and lighter as you go. Erase the excess pencil lines to clean up (if you want to). Dab the hot spots with your eraser, and watch what happens. Pretty cool, huh? The spots you dab with your eraser will create a very distinct, easily identified hot spot. Now we are getting into some fancy art terms such as "graduated values" and "defined reflection." Don't you feel like a collegiate fine arts grad student? All this fun and we are only finishing Lesson 3 and you are still with me! Way to go!

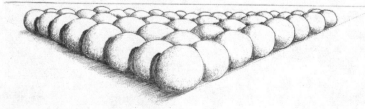

In three lessons you have learned a lot:

Draw objects larger to make them look closer.
Draw objects smaller to make them recede.
Draw objects in front of other objects to punch them out in 3-D.
Draw objects higher in the picture to make them look farther away.
Draw objects lower in the picture to make them look closer.
Shade objects opposite the light source.
Blend the shading on round objects from dark to light.

Lesson 3: Bonus Challenge

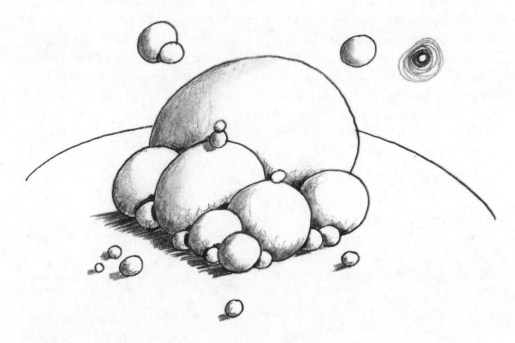

Take a look at this drawing.

Whoa! I broke just about every lesson rule so far! The largest sphere is the far-thest away.

The smallest sphere is the closest.

This is madness! Has everything you've learned over the past few lessons been thrown out the window? Absolutely not. I created this drawing specifically to illustrate how some of the drawing laws hold much more visual illusion power than others.

I compare this varying level of visual power to a few of my son Anthony's fun obsession with Yu-Gi-Oh cards (an expensive obsession for sure . . . up to $60 for a CARD!). Each Yu-Gi-Oh card has varying strengths to defeat an opponent's card. Say you have a Yu-Gi-Oh card titled "Marshmallow Musher." Let's say "Marshmallow Musher" has attack power of 1400 and it attacks an opponent's card, "Pickled Gnat Brain," with a defense of only 700. Well, poor Pickled Gnat Brain gets totally destroyed, wiped out, stomped, crushed. Correlation here: Each of the drawing laws has varying power over other drawing laws. . . . If you draw a smaller object in front of any other object, even a Jupiter-size planet, overlapping will prove to be all powerful and will prevail in appearing to be the closest. Some drawing laws have more visual illusion power than others, depending on how you apply them.

Look at the preceding drawing. Even though the farthest, deepest sphere is the largest, the smaller spheres overlap it, thus trumping the visual power of size. Overlapping is always more powerful than size.

Look at the drawing again. See the nearest sphere is drawn the smallest. Typically this would mean it would appear the farthest away. However, because it is isolated and placed lowest on the paper, it appears closest. Simply stated, placement trumped both size and overlapping.

I do not intend for you to commit these visual power variations to memory. These fun freaky wrinkles in the rules will naturally absorb into your skill bank as you practice.

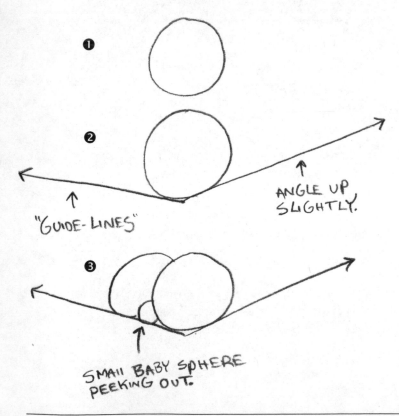

"GUIDE-LINES"

ANGLE UP SLIGHTLY.

SMALL BABY SPHERE PEEKING OUT.

1. Draw a circle.

2. Draw guide lines shooting off to the right and left. These guide lines will help you position the group of receding spheres. We will be using guide lines a lot in upcoming lessons. Draw these guide lines at just a slight angle upward, not too steep.

3. Using your guide lines, position a few more spheres behind your first. Draw the tiny one peeking out like I did below. Notice how I made use of the guide lines to position the spheres.

4. Continue to use your guide lines as a reference, and draw a few more spheres, varying the sizes. Notice how the guide lines help you place the spheres higher up in proper position (placement).

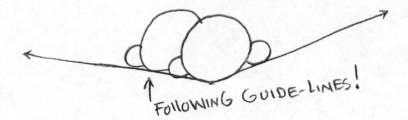

FOLLOWING GUIDE-LINES!

5. Throw some Big Mama spheres in there. Overlapping is the power principle here; even though some of the spheres are very small, they still overpower the larger spheres to appear closer. Overlapping is trumping the power of size!

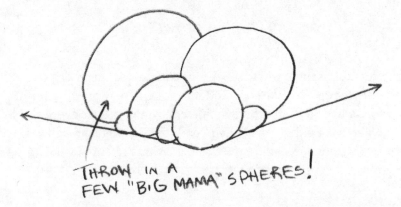

THROW IN A FEW "BIG MAMA" SPHERES!

6. Because this drawing is all about enjoying yourself, go ahead and stack a few spheres on top.

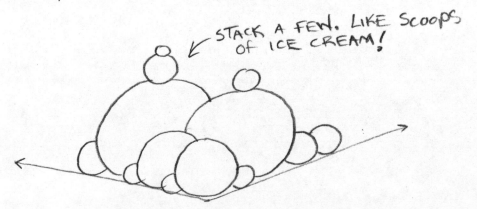

STACK A FEW. LIKE SCOOPS OF ICE CREAM!

7. Some of the spheres are breaking from the pack, seeking a less crowded, less congested life. Brave solitary spheres are establishing the first rural outposts.

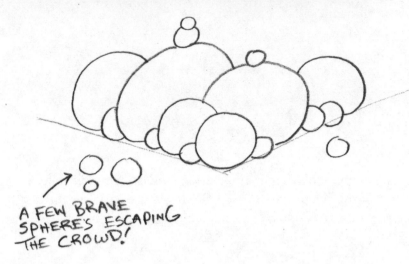

A FEW BRAVE SPHERE'S ESCAPING THE CROWD!

8. Here's the greatest sphere of all, except, of course, for the enormous Jupiter-size sphere the entire group is settled on. And now for the new drawing term: "horizon." Drawing a horizon line adds an effective reference line for your eye, establishing the illusion that objects are either "grounded" or "floating." Usually I draw the horizon line with a very straight line behind my objects. In this picture I want to create the planet feel, so I've curved it quite a bit. Looks cool, eh?

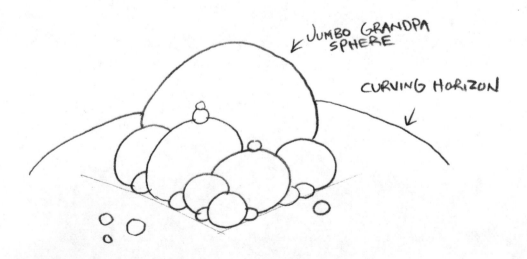

JUMBO GRANDPA SPHERE

CURVING HORIZON

9. Go ahead and draw a few more planets in orbit above the sphere pile. Take this idea of "adding extras" as far as you want. Go ahead and draw a row of thirty-seven planets in the sky overlapping down to the horizon.

10. Identify the position of your light source, and begin adding cast shadows opposite your light position. For consistency I'll keep my light source positioned in the top right, even though I'm tempted to slap it over to the left side just to throw a curve ball at you! I'll save that sudden light source position change for some later lesson. . . . You are now forewarned!

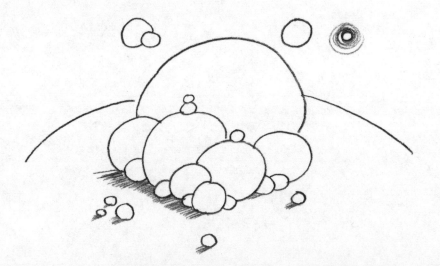

11. This nook and cranny step will take some thinking. Keep darting your eye between your light position and the objects you are shading. Put some pressure on your pencil, and get a really nice dark shadow into all the nooks and crannies. Take your time; this is a fun step in the lesson, so enjoy yourself!

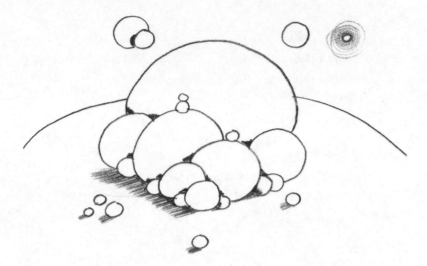

12. On the first shading pass, let your pencil fly over the spheres, just lightly shading the large areas opposite the light source. Don't worry about the blending yet; just lay down a base layer to work from.

 Make several more shading passes over all the spheres. Really work the dark edges, the dark nook and crannies, and the dark spaces on the ground between the spheres and the cast shadow. Work the blending slowly up toward the light. Constantly dart your eyes back to confirm the position of your light source. Take your time, work this well, and enjoy the exhilarating punch-out effect you are creating. You see? Drawing in 3-D is easy with me!

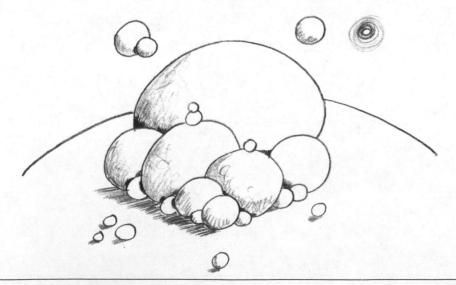

13. Blend your shading as smooth as glass. If you haven't had time to purchase a handful of blending Stomps, your finger will do just fine. Use controlled, careful pressure to smudge and smear the shading, blending it lighter and lighter from the darkest dark edges to the lightest brightest hot spot on each sphere. Work this for a while. The smoother you make the blended light transition from dark to light, the more "glasslike" the surface will appear. "Smooth as glass" is a nice segue, allowing me to introduce another great term: "texture."

Texture gives your objects a "surface feel." You could draw curving, spiral, wood–grain lines all over these spheres and create the illusion that they are made of wood. You could scratch a ton of hair onto each sphere, and suddenly you would have a very strange look-ing alien family of furry blobs. Texture can add a lot of identifying character to your drawing. (More on this great principle in later lessons.)

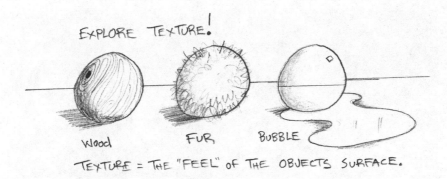

14. Adding extras to your drawing adds another layer to your learning. I can and will teach you the specific skills you need to create technically accurate three-dimensional drawings. However, the real learning, the real fun, the true enjoyment of drawing come from you internalizing the skills and externalizing your creative imagination.

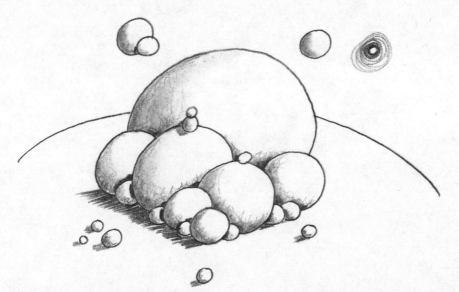

I've been driving my four-year-old son around a lot lately, hour-long commutes to downtown Houston. As soon as we start the trips, he happily demands, "Elmo! Elmo! Elmo!" So off with my preset NPR, and in with the Elmo CD. I've got the songs memorized now; I hear them in my head, my dreams, my nightmares! However, there is one song that I really like, even after 1,500 listening sessions: "It's amazing where you can go with your imagination! The things you will see, the sounds you will hear, the things you will be!"

Who knew? Elmo is a little red furry dude of wisdom. I can teach you how to draw, easy, no problem. The fun part is how you launch from this starting point by practicing, practicing, practicing . . . all the while adding, adding, adding tons of your own brilliant creative imaginative extras.

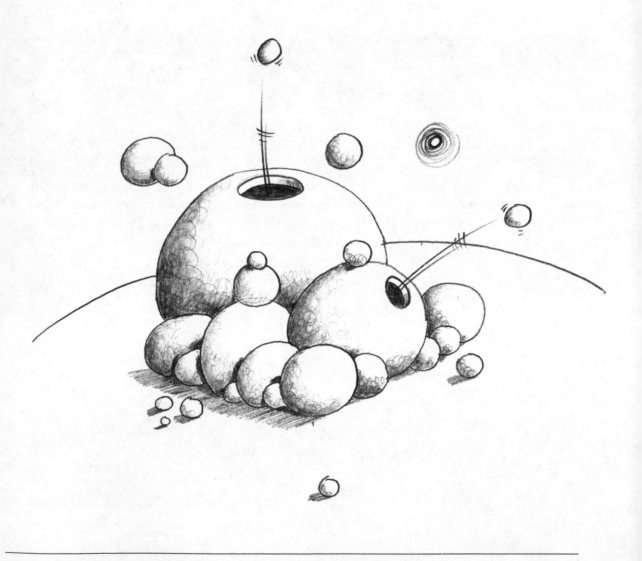

Try drawing a few holes in the larger spheres. Holes and windows are great practice exercises for learning how to draw thickness correctly. Here is an easy way to remember where to draw the thickness on windows, doors, holes, cracks, and openings:

If the window is on the right, the thickness is on the right.
If the window is on the left, the thickness is on the left.
If the window is on the top, the thickness is on the top.

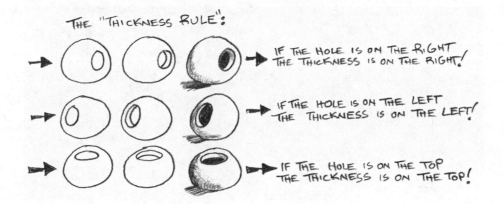

THE "THICKNESS RULE":

IF THE HOLE IS ON THE RIGHT THE THICKNESS IS ON THE RIGHT!

IF THE HOLE IS ON THE LEFT THE THICKNESS IS ON THE LEFT!

IF THE HOLE IS ON THE TOP THE THICKNESS IS ON THE TOP!

You can see I had some fun with this lesson. I started going crazy and added windows with boulders launching from them. I was about to draw a bunch of doors, skateboard ramps, and hamster travel tubes between the spheres. I pulled my pencil back at the last second, not wanting to overload you with too many ideas, too fast. Then again, why not? Go for it!

I STARTED DRAWING A STACK OF SPHERES AND ENDED UP WITH AN URBAN OLIVE CONDO COMPLEX. YOU NEVER KNOW WHERE YOUR IMAGINATION AND PENCIL WILL GO...

Take a look at a few examples of how other students completed the lesson. You can begin to see unique drawing styles beginning to emerge. Each student will have his or her own unique approach to the lessons.

Student examples

By Marnie Ross

By Kimberly McMichael

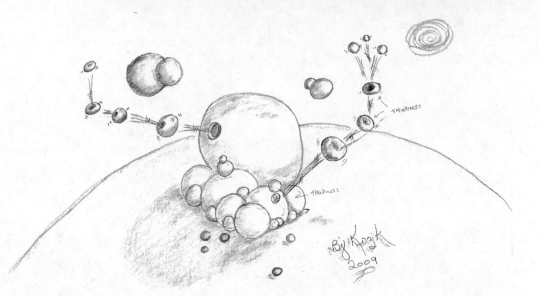

By Brenda Jean Kozik

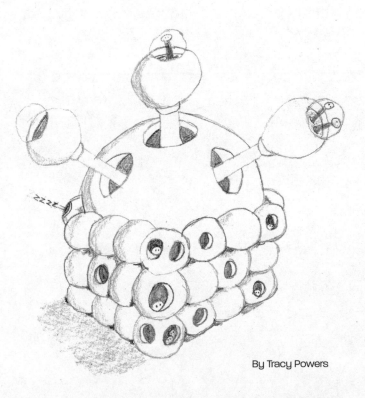

By Tracy Powers

THE CUBE

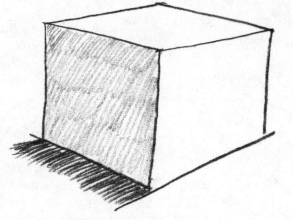

*H*ad enough spheres for a while? Let's move on to the all-important, extremely versatile, always-a-crowd-pleaser cube. The cube is so versatile that you will be using it to draw boxes, houses, buildings, bridges, airplanes, vehicles, flowers, fish . . . fish? Yes, a cube will even help you draw a fine-finned fish in 3-D. Along with helping you draw faces, flowers, and, well, just about anything you can think of or see in the world around you. So let's draw a cube.

1. Starting on a fresh new page in your sketchbook, write the lesson number and title, date, time, and your location. Then draw two dots across from each other.

2. Place your finger between the dots using the opposite hand you are drawing with. Then draw a dot above your finger as shown.

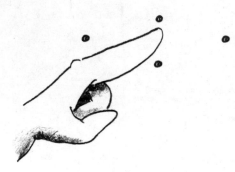

Feel free to write journal entries, quotes, notes, and anecdotes in your sketchbook. The more you personalize your sketchbook, the more you will value it, and the more you will use it. Look at my sketchbook pages: I write journal entries, self-reminder notes, grocery lists, to-do items, airline times, and all kinds of nondrawing stuff. My sketchbook is the first place I look when I need to remember something I was supposed to do.

3. Look at the dots you have drawn. Try to keep these two new dots really close together. We are about to draw a "foreshortened" square.

4. Shoot the first line across.

KEEP MIDDLE DOTS CLOSE TOGETHER!

5. Draw the next line.

6. Add the third line.

7. Complete the foreshortened square. This is a very important shape to practice. Go ahead and draw this foreshortened square a few more times. WARNING: Draw the two middle dots *very* close together. If these dots are drawn too far apart, you will end up with an "open" square. We are aiming for a foreshortened square.

Foreshortening means to "distort" an object to create the illusion that part of it is closer to your eye. For example, pull a coin out of your pocket. Look at the coin straight on. It is a flat circle, a 2-D circle that has length and width (two dimensions) but lacks depth. The surface is at an equal distance from your eye. Now, tilt the coin slightly. The shape has changed to a foreshortened circle, a circle that has depth. The coin now has all three dimensions: length, width, and depth. By tilting the coin slightly, you have shifted one edge farther away from your eye; you have foreshortened the shape. You have distorted the shape.

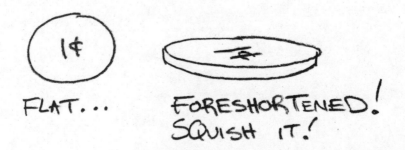

FLAT... FORESHORTENED!
 SQUISH IT!

This is basically what drawing in 3-D boils down to, distorting images on a flat two-dimensional piece of paper to create the illusion of the existence of depth. Drawing in 3-D is distorting shapes to trick the eye into seeing drawn objects near and far in your picture.

Now, back to my warning about drawing the two middle dots too far apart. If your dots are too far apart, your foreshortened square will look like this.

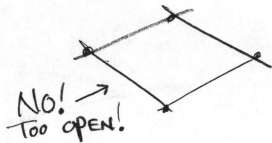

If your foreshortened square looks like the open square I just mentioned, redraw it a few more times, placing the middle dots closer together, until your shape looks like this.

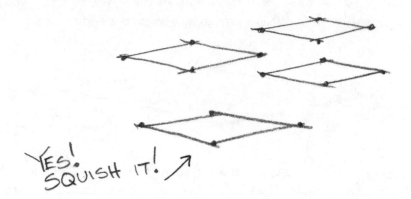

Okay, enough about foreshortening for now. Keep this concept in mind; it is so important that just about every lesson in this book will begin with it.

8. Draw the sides of the cube with two vertical lines. Vertical, straight-up-and-down lines will keep your drawings from "tilting." Here's a tip: Use the side of your sketch-book page as a visual reference. If your vertical lines match up with the sides of the page, your drawing will not tilt.

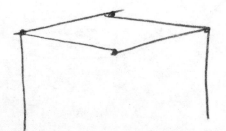

9. Using the two side lines you have just drawn as reference lines, draw the middle line a bit longer and lower. Using lines you have already drawn to establish angles and positions for your next lines is a crucial technique in creating a 3-D picture.

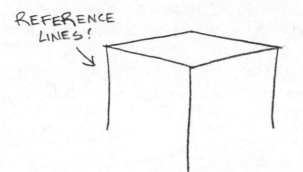

10. Using the top right edge of the top foreshortened square as a reference line, draw the bottom right side of the cube. It's a good idea to shoot this line across in a quick dashing stroke while keeping your eye on the top line. It's perfectly okay to over-shoot the line as you can clean up your drawing later. I prefer a picture that has a lot of extra lines and scribbles that look 3-D, rather than a picture that has superclean precise lines yet looks wobbly and tilted.

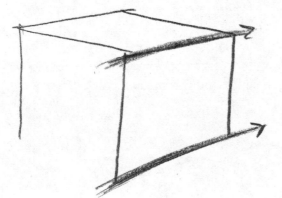

11. Now draw the bottom left side of the cube by referring to the angle of the line above it. Reference lines! Reference lines! Reference lines! Can you tell that I'm strongly urging you to practice using reference lines?

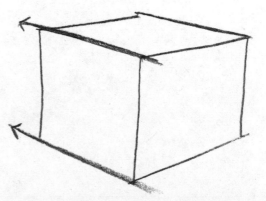

12. Now on to the fun part, the shading. Establish the position of your imaginary light source. I'll put mine in the top right position. Check this out. I'm using a reference line to correctly angle the cast shadow away from the cube. By extending the bottom right line out, I have a good reference line to match up each drawn line of the cast shadow. Looks good, right? Looks like the cube is actually sitting on the ground? This is the "POP" moment, the instant your drawing really thrusts off the flat surface.

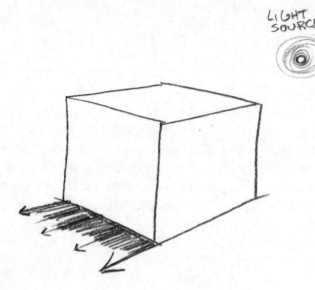

13. Complete your first 3-D cube by shading the surface opposite your light position. Notice that I am not blending the shading at all. I blend the shading only on curved surfaces.

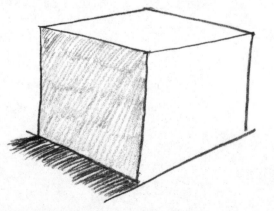

Lesson 4: Bonus Challenge

Let's take what we learned in drawing the basic 3-D cube and add details that enhance and identify the cube as three different objects.

1. We are going to draw three cubes in a group. Start the first one with your two guide dots. I'm going to be referring to these positioning dots as "guide dots" for the rest of the book.

2. Use your index finger to position the middle guide dots. This is a terrific habit to establish now, early in your drawing skill development, so that by the end of Lesson 30 using them will be second nature to you.

3. Connect the foreshortened square. This is a great shape to practice in your sketchbook if you have only a minute or so to doodle. Say you are in line at the bank drive-through with four cars ahead of you. You throw your car into park, whip out your sketchbook, and dash out a bunch of foreshortened squares. Don't worry about needing to keep an eye out for the line advancing; a chorus of car horns will politely remind you when it's time to move forward. Always keep your drawing bag handy, as you never know when you'll have a few spare minutes of downtime to practice a sketch.

4. Draw the vertical sides and the middle line of the cube. The middle line is always drawn longer and lower to make it look closer. Use the side of your sketch page as your reference line.

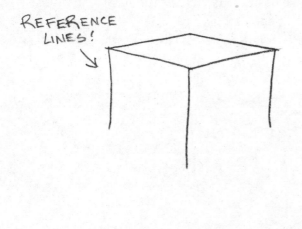

REFERENCE LINES!

5. Complete the cube using the top lines as reference lines.

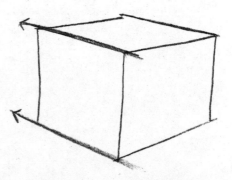

6. Go ahead and draw three cubes like I have drawn.

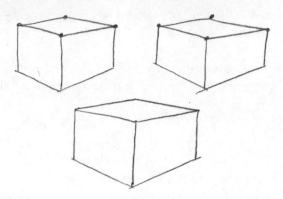

7. Draw guide dots in the middle of each side of the top foreshortened squares.

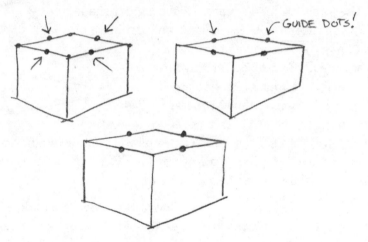

GUIDE DOTS!

8. Let's take this one cube at a time. On the first cube, let's draw an old-fashioned gift-wrapped postal package, the kind we used to get from Grandma at Christmas: a box wrapped in brown butcher paper and tied in string.

 Shoot a vertical line down from the near left guide dot; then draw it across the top to the other guide dot.

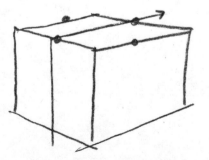

9. Repeat this on the other side. Look at how you have forced the string to flatten across the top. The guide dots helped you draw the string inside of a foreshortened boundary. Guide dots are extremely helpful in lining angles up like this. You'll see how often we use guide dots in the upcoming lessons (a lot!).

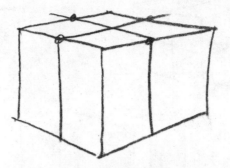

10. To draw string wrapping around the sides of the package, use guide dots once again to position the angles. Draw guide dots halfway down each vertical edge.

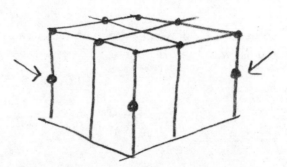

11. Draw the string by connecting the guide dots, using the line above as your reference line.

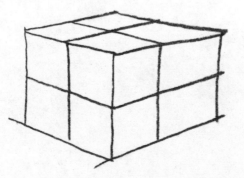

12. With this basic string wrap, you can finish all three cubes into a package, a cube game, and a gift wrapped in thick ribbon.

Go ahead and have some fun: Try drawing a group of five cube games each overlapping the other, like you did with the five spheres!

By Kimberly McMichael

Place a shoebox or a cereal box or any kind of box on the table in front of you.

Photo by Jonathan Little

Sit down and position yourself so that you can see the foreshortened top of the box, similar to the foreshortened shapes you have just drawn in this lesson. Now, draw the box sitting in front of you.

Don't panic! Just remember what you learned in this lesson, and let this knowledge of foreshortened squares help your hand draw what your eyes are seeing. Look, really look, at the foreshortened angles, the shading, and the cast shadow. Look at how the lettering on the box follows the foreshortened angles at the top and bottom of the box. The more you draw, the more you will really begin to see the fascinating details in the real world around you.

By Suzanne Kosloski

HOLLOW CUBES

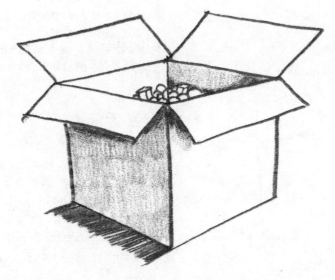

*T*o teach you how to really feel like you are gaining control over that daunting flat piece of paper, I want to explore the challenging fun of hollow boxes and cubes.

1. Go ahead and lightly sketch in the cube.

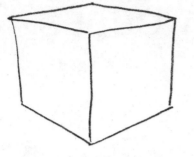

Parallel and Perpendicular Lines

Parallel lines are two lines going in the same direction, spaced equally apart. In my mind I picture the word "parallel" and see the two *l*'s together in the word. Perpendicular lines are two lines that intersect at right angles to each other. For example, this line of type text is perpendicular to the right edge of this book page.

2. Slant back two parallel lines.

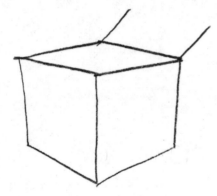

3. Alignment alert! Look how I have drawn this top edge of the box lid in alignment with all of the angled lines slanting slightly up to the left. I'm going to refer to this angle as direction northwest. Think of a compass.

The four most commonly used line directions that I will be referring to throughout this book will be lines drawn in directions northwest, northeast, southwest, and southeast. Take a look at this compass.

Now, I'll foreshorten the compass. As you recall, foreshortening is distorting or squishing an object to create the illusion of depth, to make one edge of the object appear closer to your eye.

Notice in this foreshortened compass illustration that the four directions—NW, NE, SW, and SE—all line up with the lines you already used to draw your cube.

FORESHORTENED
3-D

I call this my "Drawing Direction Reference Cube." This is a wonderful tool to help you position your lines consistently in proper alignment. Without consistency in your angles, your drawings will "droop" or look askew. Dr. Seuss achieved world acclaim for his signature style of drooping, melting, Play-Doh-ish characters, buildings, objects, and environments. However, in his work, Dr. Seuss still maintained consistent drawing compass angles. Good examples of this are in his book *The Lorax*. Turn to any page in *The Lorax*, and hold up the Drawing Direction Reference Cube to the illustration. You will discover that his buildings, windows, doors, pathways, vehicles, and characters all follow these four important positions.

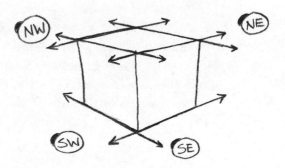

4. Draw the other side of the box lid lifting up with two parallel lines.

5. Using the bottom of the box line in direction NE, draw the top of the lid in direction NE.

6. Sketch in the two near lid flaps slanting down in front of the box.

7. Once again, using the bottom of the box angles to guide your line directions, complete the near flaps, aligning them up in direction NE and NW. I will be repeating this idea often: Use the lines you have already drawn as reference angles to draw additional lines. By always referring to the lines you have already drawn and by continually checking your angles against the Drawing Direction Reference Cube, your drawings will look solid, focused, and, most importantly, three-dimensional.

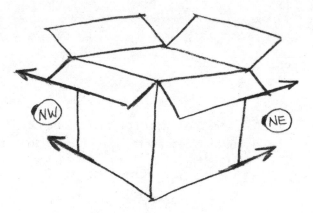

8. Draw the short "peeking" line at the back interior of the box. I am still delighted (after all these years) with the visual power that one little line has on the overall three-dimensional illusion of a drawing. This little peeking line at the back of the box creates the "BAM!" (as Emeril would say) moment in our drawing—the one precise moment that the sketch transforms from a two-dimensional sketch into a three-dimensional object.

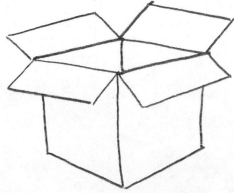

9. Establish your horizon line and your light source position.

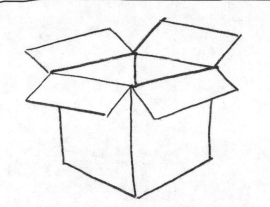

10. To properly draw the cast shadow, use the Drawing Direction Reference Cube as reference. Draw a guide line extending from the bottom of the box line in drawing direction SW. Droop alert! This is the most common point where students tend to droop the cast shadow guide line. Notice how my cast shadow lines up with my guidelines.

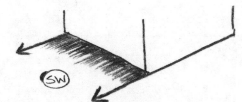

Be careful not to droop your cast shadow like this.

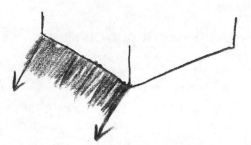

11. Darken under the two front overlapping flaps as I have done, creating the undershadow effect. Undershadows are terrific little details that successful illustrators exploit to pop out objects, refine detail, and sharpen edges. In this specific drawing, undershadows have the power to really pull the overlapping lids toward your eye, while pushing the actual box deeper into the picture.

12. This is the most rewarding step of each lesson. Clean up your sketch by erasing the extra sketch lines, and sharpen the outside edges of the drawing by darkening the outline. This will thrust the image out away from the background. Finish shading the left side of the box and inside the box, away from your light source. I always encourage you to have fun with these lessons by adding lots of extra details, neat little ideas you creatively conjure up to spice up your drawing. I've put a few small items in the box, just barely visible. Notice how even these little details add a lot of visual flavor and fun to the sketch.

Lesson 5: Bonus Challenge

Speaking of adding extra details to enhance your drawing, let's expand on the cardboard box lesson. How about a treasure box overflowing with pearls, coins, and priceless loot? We are all so stressed about the economy, our mortgage payments, and health insurance premiums, so let's take a reality vacation and draw our own wealth.

1. Beginning with our basic cube, go ahead and draw in the Drawing Direction Reference Cube direction lines for good practice and memory imprint. Slant the sides in just a bit.

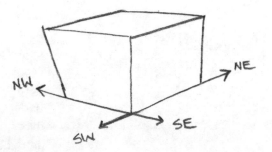

2. Draw two parallel lines slightly opening the top of the treasure chest.

3. Using the lines you have already drawn (sound familiar?) as reference, draw the top edge of the lid in the NW direction.

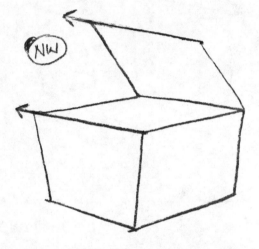

4. Draw the near curving edge of the lid.

5. Using the lines you have already drawn (am I sounding repetitive?) as a reference, draw the top edge of the lid in direction NW. Notice how I slanted my top edge line a bit more than a direction NW line. This is because eventually all these NW direction lines will converge on a single vanishing point. I will explain this vanishing-point concept in great detail in a later lesson. For now, just follow my steps and slant your top edge line a bit more.

6. Draw the two inside "peeking" lines. This is our "BAM" punch-out in 3-D moment; you've got to love this!

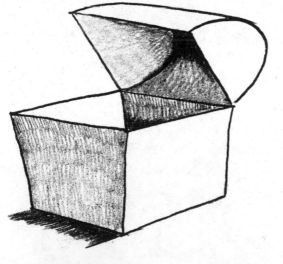

7. Detail your drawing. Clean up any extra lines. Position your light source and add shading to all the opposite surfaces, darken the undershadows, and draw the cast shadow. Enjoy drawing the extra details to this lesson. Draw overflowing money, jewels, and pearls to your heart's content!

Student examples

Take a look at how these students added some great bonus details to this lesson.

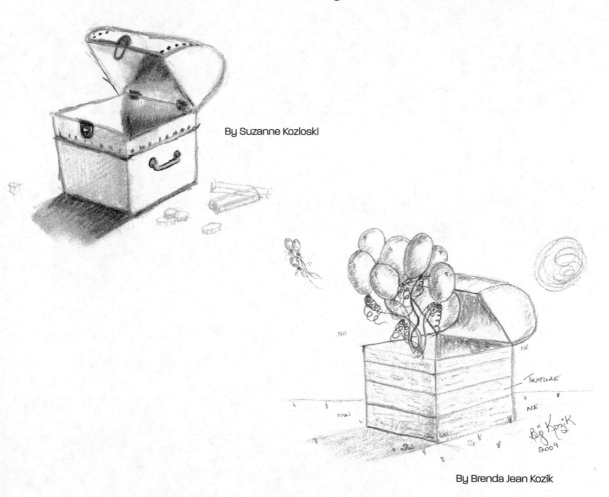

By Suzanne Kozloski

By Brenda Jean Kozik

By Ann Nelson

STACKING TABLES

*T*his is a fun and rewarding lesson that was inspired by my fifth-grade art teacher, Bruce McIntyre (Mr. Mac). His enthusiasm for teaching kids how to draw had a profound and lasting effect on me. This lesson will gel all of the concepts and laws we have been discussing so far into one very cool three-dimensional drawing. Did I mention this is a really fun lesson? I bet that you will enjoy it so much that you will be stacking cubes on every scrap of paper that happens to be within your reach.

1. Begin with a strong foreshortened square. Remember, I urge you to use the guide dots for all the lessons in this entire book. I know you are feeling very confident with your foreshortened squares, boxes, and cubes. However, humor me and use the guide dots each and every time. There is a solid reason for this, which I'll explain in detail in a later lesson. Trust me, young grasshopper; all will be revealed in time.

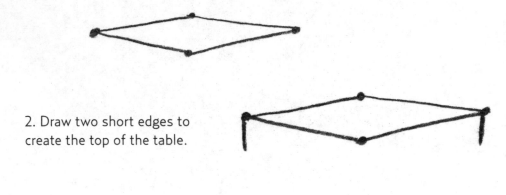

2. Draw two short edges to create the top of the table.

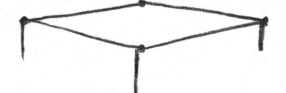

3. Draw the middle line longer, using what extremely important drawing concept?

4. Using the lines you have already drawn as reference, draw the bottom of this table top in directions NE and NW.

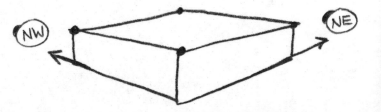

5. Draw the middle line longer to create the near edge of the table post.

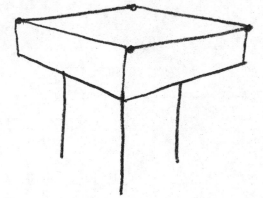

6. Draw the sides of the table post as I have done. Notice how each side line is drawn halfway from the far edge to the middle line. Look at my example. This is definitely a case where a picture is better than a bunch of words.

7. Using the lines you have already drawn as reference (I'm actually going to start cutting and pasting that sentence in each of these steps!), draw the bottom of the table post in directions NW and NE.

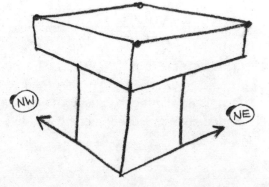

8. Draw the horizon line just above the table, and position the light source above and to the right. I'm drawing the horizon line at this stage in the lesson to illustrate an important concept to you. All the drawings we have completed so far have been drawn from an above point of view (point of perspective), looking down at the object. The horizon line tells our eye that the object is below the horizon line, which communicates to our brain that the thickness, shadows, and foreshortening are from this perspective.

The word "perspective" is rooted in the Latin *spec*, meaning "to see." Think of spectacles, or eyeglasses, as assistance in seeing; a spectator as someone who sees an event; and speculation as the act of seeing possibilities. Perspective is the process of seeing the illusion of depth on our two-dimensional surface. In later lessons I will be teaching you how to draw objects *above* the horizon line with one-point and two-point perspective. For now, just remember that the position of the horizon line is above the object if you draw it in a looking-down point of view.

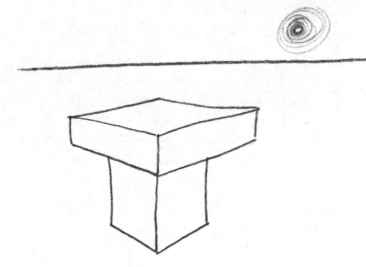

9. ALERT! Very important step! Place a guide dot directly below the near corner of the table post. Many students forget to use this guide dot during this exercise—to the detriment of their drawings. If you don't use the guide dot on every stacked table, your drawing may get progressively more skewed and impossibly distorted. A cool visual effect if you are channeling Andy Warhol, but a disaster if you are aiming for a sharp, focused, properly proportioned, foreshortened three-dimensional stack of tables.

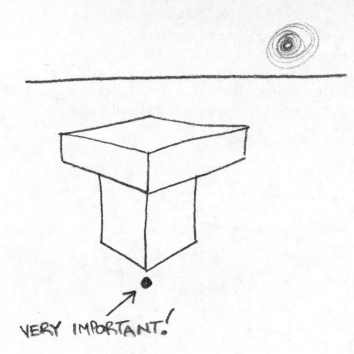

VERY IMPORTANT!

10. Using the lines you have already drawn as reference (yes, again!), draw the front edge of the pedestal in directions NW and NE.

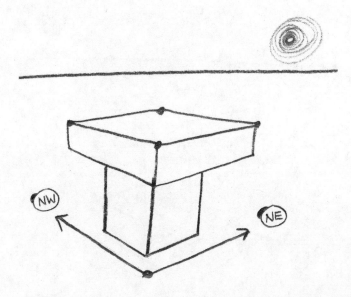

11. ALERT! When you draw the back edges of the top of the pedestal, be sure to go behind the corner of the post. These two very short lines need to be lined up with the lines you have already drawn in directions NW and NE. This is the second most common mistake students will make drawing this lesson. Students have a strong tendency to connect these two short lines directly to the post corners. Fight your instinct to connect corners! Draw these lines behind the post.

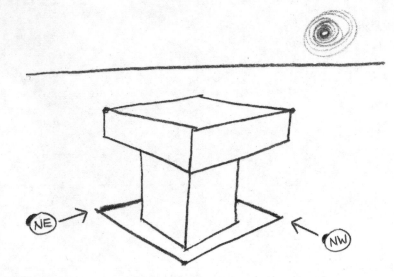

12. Complete the pedestal, making sure to draw the near corner lower. As always, use the lines you have already drawn as reference angles for drawing the bottom lines of the pedestal in directions NW and NE.

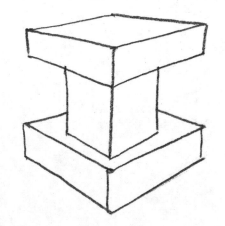

13. Using the lines you have already drawn for reference, extend out the cast shadow direction guide line.

14. Add the cast shadow opposite your positioned light source, shade the table and pedestal, and add the dark undershadows of both sides of the post. Notice how that nice dark undershadow really pushes that post deep under the tabletop. There it is, another BAM moment for our lesson!

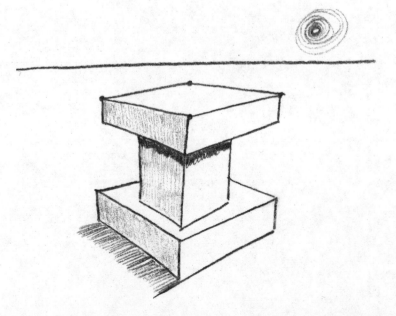

Here's a great way to really get the important points of this lesson. Find a watch, clock, or cell phone that reads a second hand. I want you to time yourself drawing this single table on a pedestal. Try it two or three times with a timer, and see if you can get your completion time down to two minutes. I do this timed exercise with all of my students from elementary school grades all the way up through my university workshops. The purpose of having you draw this image in a specific amount of time is to train your hand to confidently draw these foreshortened shapes and overlapping corners and, most importantly, to embed the drawing compass angles into your hand memory. The angles NW, NE, SW, and SE will begin to have a certain comfortable feel to them. The more you practice this single table with a pedestal, the more comfortable and confident your lines will be in all of the upcoming lessons and all of the drawings you will ever create in the future. This is an excellent drawing exercise to dwell on for several days.

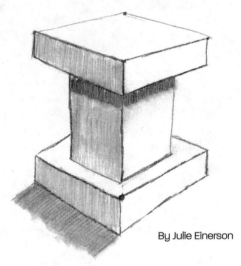

By Julie Einerson

Lesson 6: Bonus Challenge

Now, for the really fun level of this lesson. Just how far do you want to stretch your drawing skills today? Take a look at my drawing journal page.

You can see that I really enjoyed myself with this supertall, curving table tower. Now take a look at a few student examples of this same exercise.

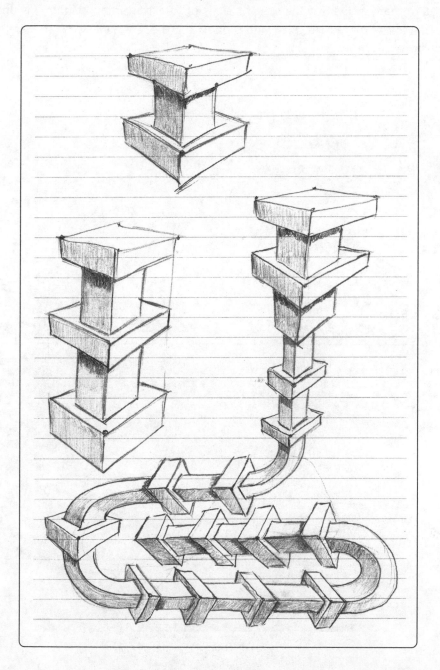

Student examples

Do you have fifteen more minutes to try one of these monster table towers? Sure, go for it! Be sure to note your start time and your end time on your sketch page. I'm fairly certain you'll end up spending several fifteen-to-thirty-minute chunks of your day doodling these wonderful wacky table towers. Not only are they terrific practice exercises to really nail down the specific skills of foreshortening, alignment, under-shadow, shading, placement, size, and proportion; these table towers also are addictively fun to draw.

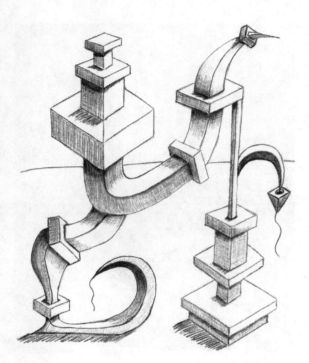

By Michele Proos

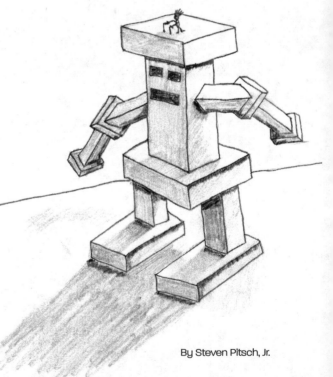

By Steven Pitsch, Jr.

ADVANCED-LEVEL CUBES

*I*n this lesson I want to build on this pivotal skill of drawing three-dimensional cubes. I want you to be able to have complete control of drawing the cube and the ability to manipulate it into many more advanced shapes. You will soon discover in later chapters that the ability to manipulate the cube will enable you to draw a house, a tree, a canyon, and even a human face. "How can you transform a boring cube into a tree or a human face?" you ask. I'll tell you . . . later, but first . . .

1. Using guide dots (as you will for all the lessons of this book, right?), draw a well-practiced sharp foreshortened square.

2. Lightly draw the sides down, and draw the middle line longer (sketch lightly as these are just the beginning shape-forming lines).

3. Draw the bottom of the cube using the lines you have already drawn as reference. For the purpose of review, go ahead and extend all of your direction NW and NE lines out as I have done here.

4. Draw the all-important guide dot just below the near corner. This guide dot determines the angle of your foreshortened second layer. If your guide dot is placed too low, it will distort the layer and throw the entire building out of alignment.

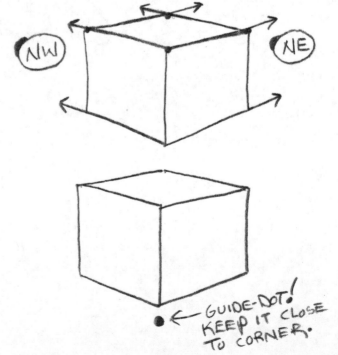

GUIDE-DOT! KEEP IT CLOSE TO CORNER.

5. Using the lines you have already drawn for reference, draw the near edges of the second tier in directions NE and NW. When I am drawing my own illustrations, I still dart my eyes back and forth constantly between my first "primer" compass angles to each line angle I am adding. Think of how many times each minute you glance at your rearview mirror while driving. You do this without even thinking, because it is so deeply ingrained in your subconscious. This is exactly the level of comfort, ease, and habit I want you to form with this constant, vigilant reference to your drawing compass angles.

6. Look at your NE angle at the top foreshortened square of your box. Now, look at all the NE drawing compass direction arrows you drew in step 3. Now, take your pencil and trace over those direction lines lightly to embed the angle of the line into your hand memory. After a few of these rehearsal pencil strokes, quickly move your hand to the left of the cube and draw the direction NE line behind the corner. Repeat this same technique to draw the NW line on the other side to create the top of the second layer of the building. I do this rehearsal shadow drawing all the time, with every drawing I create. I am constantly referring back to my initial foreshortened square source, shadow drawing the angles again and again before dashing off the lines that build my drawings.

7. Complete the second layer of the building. Double-check your bottom lines against drawing compass direction arrows NW and NE.

⑧

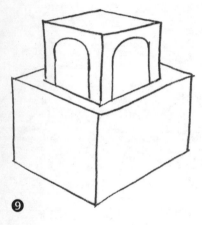

⑨

⑩

8. Begin drawing the doors on the top level with two vertical lines on each side. To make sure your lines are actually vertical, straight up and down, look at the edge of your paper. All of your vertical lines should be parallel with the edge of your paper. You should glance at the vertical edge of your paper every time you are drawing a vertical line, or you run the risk of the objects in your picture severely leaning over to one side or the other. Here's an interesting point to note: The near edge line of each doorway needs to be drawn a bit larger than the far edge line. This uses the important concept of size. The near part of the door needs to be drawn larger to create the three-dimensional illusion that it is actually closer to you. This underscores a fundamental principle of drawing: To make an object appear closer to your eye, draw it larger than other objects in the picture.

9. Curve the tops of both doorways on the top floor of the building.

10. To create the illusion that these doors actually exist as three-dimensional entrances to this building, we need to add thickness to them. Let's review the simple thickness rule:

If the door is on the right, the thickness is on the right. If the door is on the left, the thickness is on the left.

Memorize this rule, repeat it, and practice it (I teach this rule to my university students as often as I do to my elementary school students). This thickness rule will always apply—to any door, window, hole, or entrance to any object you will ever draw. Knowing this rule by heart will get you out of many a drawing quandary in complicated renderings.

Let's begin applying this important thickness rule to the door on the right side first. If the door is on the right, the thickness should be on which side? Yes, you've got it: the right. Using your drawing compass lines in direction NW, draw the bottom thickness on the right side of the doorway.

11. Complete the door by following the line of the exterior door as it curves up.

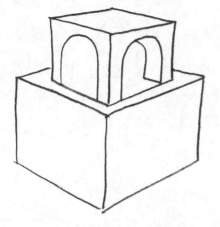

12. Look at the door on the left side. Using the drawing compass direction NE lines you drew earlier as reference, draw the thickness on the left-side door on the left side of the entrance.

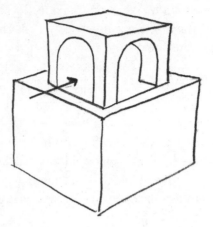

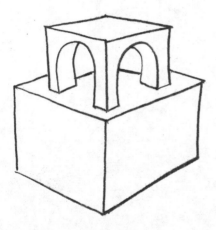

13. Erase your guide lines at the bottom of each door. With a well-placed line in drawing directions NW and NE, you can easily create the visual illusion that there is a hallway or a room inside each doorway. Notice how I have drawn these lines just a bit higher than the bottom thickness line of each doorway. By nudging this line up, I create more space.

14. Now, with some interesting wedges you can develop these into entrance ramps or quick-exit-end-of-workday slide ramps or skateboard ramps for your kids. This is a great example of why drawing in three dimensions is such a magical skill to master. You are developing the skills to create buildings, cities, forests, or entire worlds on a blank two-dimensional piece of paper. One pencil, one piece of paper, your imagination, and the skills I am teaching you here are all the ingredients you need to create your own world. Not a bad way to spend thirty minutes of your day, right?

Draw two guide dots on either side of the building.

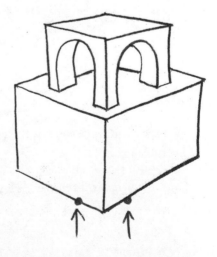

15. Let's create the ramp on the left side first. Draw the vertical back edge of the ramp against the wall, and extend the bottom edge of the ramp out in drawing compass direction SW. We used this direction often when drawing our guide lines for cast shadows in our previous lessons. In fact, we will be using this SW direction line again for a cast shadow on this building a little later in this lesson. Be vigilant in maintaining this direction SW line. Triple-check it against your earlier lines in NE because NE and SW lines are identical, just a different stroke direction of your hand. This is definitely an idea that is much easier to explain with visual examples than with words.

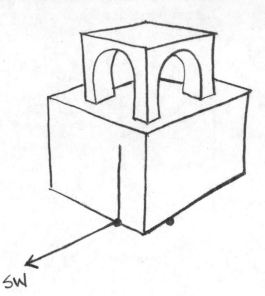

SW

16. Complete the near edge of the ramp.

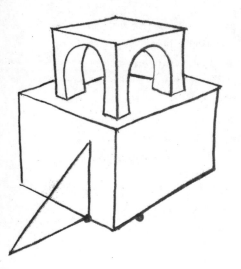

17. Draw the thickness of the ramp with two lines in direction NW, matching the angles with the lines you drew earlier in direction NW.

NW

SW

18. Complete the far edge of the ramp by matching the angle of the front edge (another good example of parallel lines). Notice how I have drawn the bottom of the face or the ramp a tiny bit larger than the top. You must always keep in mind the effect of size in your drawing. To reiterate, to make objects appear closer, draw them larger. To make objects appear farther away, draw them smaller. In this case, I want to draw the bottom of the face of the ramp a bit larger to strengthen the visual illusion that it is closer to your eye and that the top of the ramp is pushed deeper into the picture, farther from your eye. It's this constant application of these small details, using these important drawing laws (size, placement, shading, shadow, etc.) and the drawing compass directions (NW, NE, SW, and SE) that give you the skills and confidence to sketch anything in three dimensions.

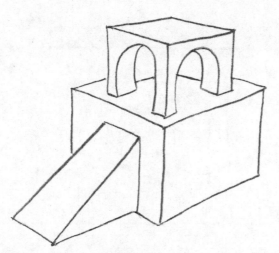

19. Erase your guide lines behind the ramp. Using the lines you already drew in direction NE as reference (keep glancing at those lines as you are drawing new ones to match up the angles), draw the ramp on the right side. Remember: Beware of the tendency to droop the bottom line. No drooping!

20. Complete your two-layered foreshortened ramp building by drawing the horizon line above the building, positioning your light source, and shading all the surfaces opposite your light position. Using your reference lines to angle the cast shadow correctly in direction SW is really simple when you are drawing buildings; just extend the bottom lines. Erase any extra lines or smudges, and voilà, you have completed your first architectural rendering. Congratulations! Beautiful job!

Lesson 7: Bonus Challenge

Here are two very interesting variations of the two-layered ramp building. In variation number one, I experimented with tapering the vertical sides inward. I was pleased with the results. You try it. However, in your version, draw it nine levels high. Now, draw a nine-section-high version, alternating the tapered sides from inward to outward. How about trying a tall version with alternating thin and thick layers, tapering three segments in, three segments out, three in, etc.? You can see where I'm going with this. There are a thousand possible variations of this interesting exercise.

In variation number two, I experimented with alternating the foreshortened layers into a rotating step building with ramps, doors, windows, and some peculiar foreshortened cylinder attached to the side. It looks much more complicated than it is. Simply start with a very strong and sharp foreshortened square. Keep in mind that the very first foreshortened square you draw is the template reference point for all the lines you will be drawing for the entire picture. With this strong beginning, enjoy the process of duplicating my variation number two, one line, one step at a time. You have enough knowledge and skill now to draw this one on your own without me having to break it down into steps for you. Be patient, take your time, and ENJOY yourself!

Student examples

Take a look at some student examples and get inspired!

By Julie Einerson

By Suzanne Kozloski

Julie Einerson has applied several principles from the lesson to this sketch of her spa.

By Marnie Ross

Marnie Ross has applied her budding drawing skill to this rendering of her church.

By Michael Lane

LESSON 8

COOL KOALAS

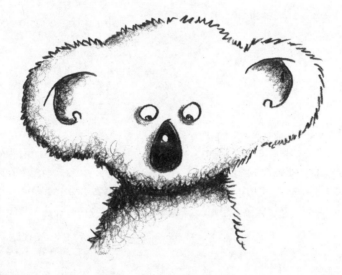

*T*oday, let's take a break from boxes and structures and draw a koala from our imagination. This lesson was inspired from my teaching tour through schools in Australia many years ago. During my school visits, the students introduced me to a wide array of exotic Australian pets. One student let me hold his pet koala, another a pet echidna, a frilled hooded lizard, a duck-billed platypus, and even a baby kangaroo.

Of course, on each occasion I had to draw the animals in my ever-present drawing sketchbook/journal. Then, of course, I just had to teach the entire class how to draw these wonderful creatures in 3-D by using the Nine Fundamental Laws of Drawing. In this lesson we will draw a caricature of a koala. After the lesson, I encourage you to go online and research three photos of real-world koalas and draw them as well by using the skills we are going to learn now.

1. Very lightly sketch three circles in a row.

2. On the first circle, use curving dashes to create a "soft fur" texture along the outside edge.

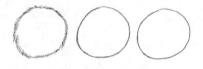

3. Continuing to work on the first circle, use more curving dashes to fill in the left side of the circle, creating the illusion of shading with texture. You can use texture to shade an object.

4. Let's take this one step further. On the second circle, draw sharp lines around the outside, creating the "feel" of sharp spikes.

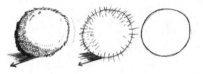

5. Place your light source in the top right corner of your page, and add a few more rows of spikes to the left side of the shape.

6. Draw scribbles around the third circle. Keep scribbling more circling lines around and around the shape to create a messy-looking ball of dryer lint. Continue to explore this idea of texture as a tool for shading.

7. Now, time for the start of this lesson—the koala! Begin with a light circle.

8. Lightly sketch in the ears.

9. Lightly slope down the shoulders.

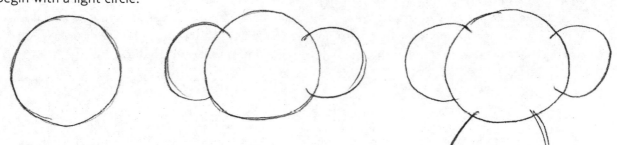

10. When you draw in the "tapered" nose, be sure to leave a small white area. This creates the illusion of a light reflection off the shiny nose. You will do this same thing when drawing other animals: cats, dogs, bears.

11. Draw the koala's eyes, transferring the idea of reflection by leaving a small white spot in each pupil.

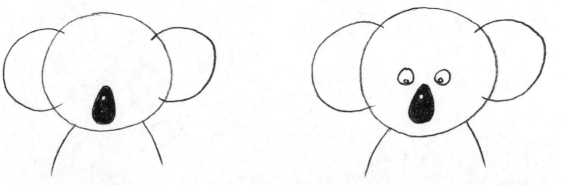

12. Let's take a closer look at the ear. This is what is known in the art world as doing a "study" of a small portion of a picture: for example, the hand of Michelangelo's Adam as he reaches out to God in the panel "Creation" on the ceiling of the Sistine Chapel or the over-lapping petal of Georgia O'Keefe's *Lily*. In this study of our koala's ear, draw the top edge of the ear, the "helix."

13. Draw the overlapped line of the "concha."

14. Draw the bump at the bottom of the ear. This is the "tragus."

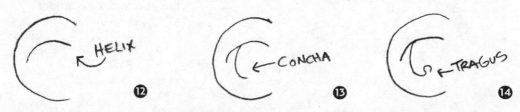

This is a perfect example of how effective visual communication can be. I could write for pages explaining what a concha is, where it's located, and what it looks like. Or I can draw a few lines on a page and point to it. Now take your finger and lightly trace the helix, concha, and tragus in your own ear. What do you know? We humans have nearly the same ear structure as koalas, and in fact all land mammals' ears have a helix, a concha, and a tragus. In future drawings you create, you'll be able to transfer this detail to other animals you want to draw.

15. Repeat this ear structure on the right ear.

16. Look back at the furry ball you drew at the beginning of this lesson. Notice how you created the soft feel of fur as compared to the sharp feel of the spike ball. Draw the soft, furry texture around the outline of the koala.

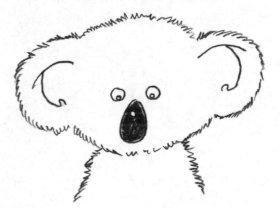

17. Use more furry texture to shade the koala's head, ears, and body. Emphasize the undershadow under his chin and in his ear under the top helix line.

Lesson 8: Bonus Challenge

Now that you have successfully drawn one cute little koala, why stop here? Go ahead and draw a crowd of them! Enjoy yourself. Use a lot of overlapping and size to push the other koalas deeper into your picture. Darken and define the edges of the nearest koala to really pull her out closer to your viewer's eye. Creating this push and pull of objects in your drawing means you have successfully achieved the delightful illusion of the third dimension, depth, in your picture. Way to go!

Now take a look at my sketchbook page for ideas on drawing a koala crowd.

Here's an idea: Search the Internet for three photos of koalas in nature. Notice how their ears and noses are in real life. Using the important concepts from this lesson—texture, shading, and overlapping—draw another koala with smaller, more realistic ears and nose.

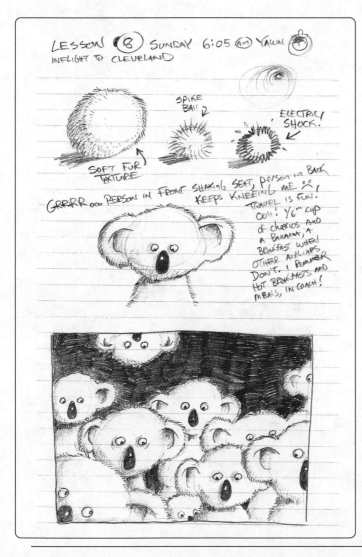

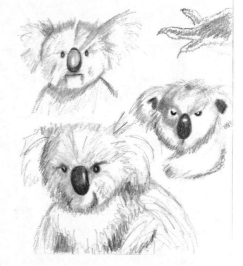

Suzanne Kozloski used the important principles from this lesson for her more realistic drawings of koalas.

Various textures found their way to my students' sketchbooks, as you can see here.

Student examples

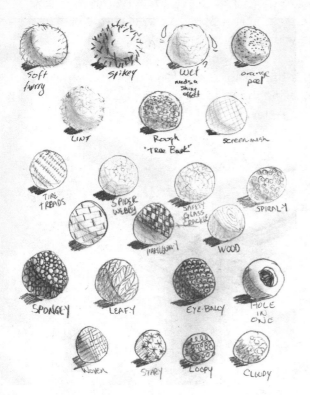

By Ann Nelson

By Marnie Ross

By Kimberly McMichael

LESSON 9

THE ROSE

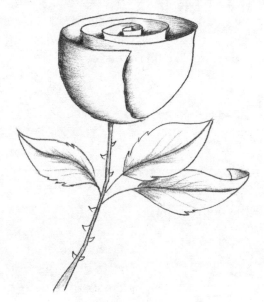

*L*et's warm up for the rose by drawing a simple bowl shape. I often tell my students that musicians warm up by playing scales, athletes warm up by stretching their muscles, and we artists can warm up by drawing several simple basic shapes, a few stacked tables, some overlapping spheres, or a delightful bowl of cereal!

1. Draw two guide dots horizontally across from each other.

2. Connect the dots with a foreshortened circle.

The foreshortened circle is one of those pivotal shapes that can be used as a foundation to create thousands of objects. Similar to the importance of a foreshortened square, enabling you to draw boxes, tables, houses, and so on, the foreshortened circle enables you to draw the three-dimensional curved surfaces of cylindrical objects: a bowl, a rose, a cub, a hat, a jellyfish. Practice drawing six foreshortened circles in a row, using guide dots, like I have here.

3. Draw the body of the bowl.

4. Using a guide line in direction SW (you'll have to draw this from memory, as you have no reference lines yet—careful, no drooping!), position the light source in the top right. Draw the horizon line. Shade the bowl with blended shading from dark to light, creating a smooth blended surface. Look at how the small bit of blended shading inside the right corner of the bowl has an enormous visual effect in creating the illusion of depth. This small blended shading detail will be very important for you to transfer when you are drawing the rose, the lily, an orchid, or any flower.

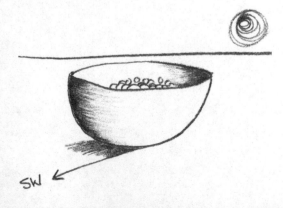

5. Before you draw the rose, I want to introduce you to an important idea I call the "peeking" line. This tiny detail of a small overlapping line that defines a fold or a wrinkle will have a huge visual effect in enabling you to make the rose petals appear to be curling around the bud in three dimensions. The best exercise to familiarize you with this is a fun simple "flapping flag" exercise.

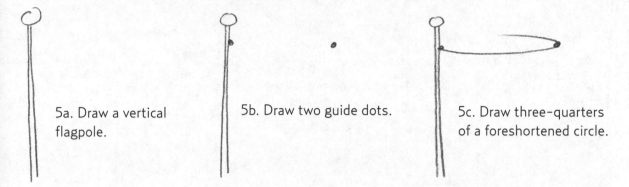

5a. Draw a vertical flagpole.

5b. Draw two guide dots.

5c. Draw three-quarters of a foreshortened circle.

5d. Draw the vertical thickness of the flag.

5e. Curve the near bottom edge of the flag a bit more than the line above it. The bottom of the flag is a bit farther from your eye, so you need to distort it, curve it more than the top edge.

5f. Draw the "peeking" line, the most important line in this exercise. This teeny tiny dash will make or break this drawing and holds an enormous amount of visual power. It uses overlapping, placement, and size simultaneously.

CURVE **MORE!**

PEEK!

5g. Okay, that was pretty cool. Let's try one in reverse.

5h. Draw the two guide points for the foreshortened circle.

5i. Draw three-quarters of a foreshortened circle, but this time curve the top edge of the flag toward you.

5j. Draw the vertical thickness lines from each edge. Make sure to draw the near edge a bit longer to make it appear closer.

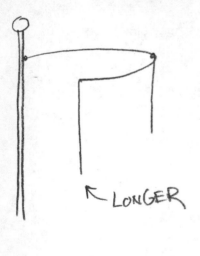

← LONGER

5k. Curve the bottom of the near part of the flag. Remember to curve it a bit more than you think you need to. Remember that distortion is your friend here.

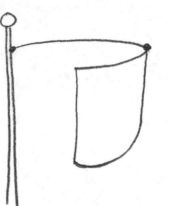

5l. Push the back line up, away from the near bottom corner of the flag. You need to curve this back line opposite the line you have just drawn. You are following the curved line above as reference, however, so the same principle of distortion applies. Curve the back line a bit more than the top edge.

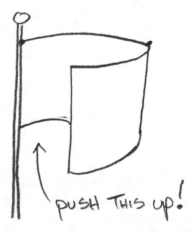

PUSH THIS UP!

5m. Now, let's apply all this distortion of fore-shortened circles to a curling flag. This exercise will be directly transferred to the rose. Draw another flagpole.

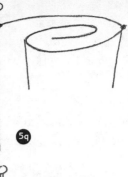

5n. Draw the two guide dots, and draw the three-quarter foreshortened circle curling toward you.

5o. Begin spiraling the foreshortened circle inward.

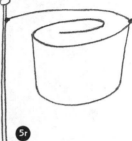

5p. Complete the foreshortened circle spiral. Stretch out the ends, and always curve the middle in close. We will also be discussing this when we draw water ripples in a later lesson.

5q. Draw the thickness of the vertical sides of the flag.

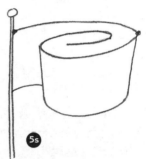

5r. Curve the bottom of the near edge of the flag a bit more than the curve you have drawn on the top edge above.

5s. Push that back line up, and curve it away from your eye.

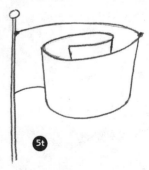

5t. Draw the all-important peeking lines from each of the inside edges. This is definitely the BAM moment of this drawing, the one instantly defining moment when a drawing suddenly pops into the third dimension.

5u. Draw in some very dark nook and cranny shadows. Generally, the more little cracks, crevices, nooks, and crannies that you can pour some shadow into, the more depth you create in your drawing. Complete the blended shading.

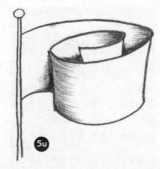

I know that was quite a bit of a warm-up exercise for this one drawing lesson. Good job on your patient cooperation in drawing the bowl and the three separate flags. We will now use the techniques you just learned to draw a rose.

6. Draw a foreshortened bowl, and add a stem.

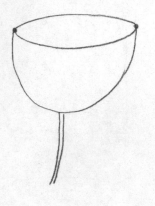

7. Draw a guide dot in the middle of the rose bowl (get the pun?).

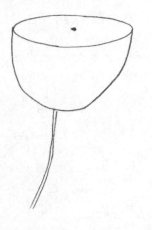

8. Begin to spiral out the rose petal with three-quarters of a foreshortened circle.

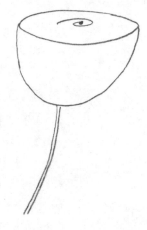

9. Keep spiraling, and keep these spiraled foreshortened circles squished. It's the distorted shape that will form the three-dimensional rosebud.

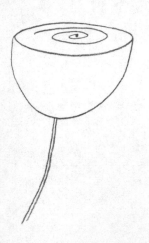

10. Complete the spiral at the center of the petal. Erase the extra line.

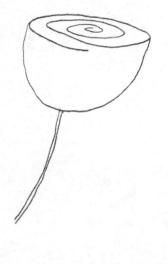

11. Draw the center thickness of the rose petal and the first peeking thickness line. We are almost at the BAM moment.

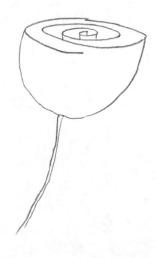

12. Draw the next outer peeking line.

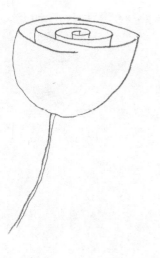

13. Draw the remaining thickness line. BAM! There it is—depth focused on our beautiful rose.

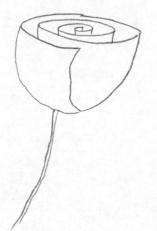

14. Draw in the very dark, very small, nook and cranny shadows. Notice I even darkened a shadow along the edge of the rose petal.

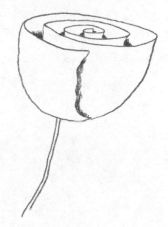

15. Place the light source in the top right, and blend the shading on each of the curved surfaces opposite. Draw a few thorns on the stem, and draw the leaves.

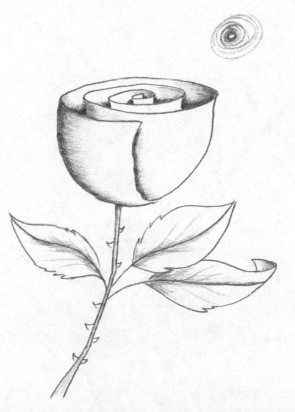

Lesson 9: Bonus Challenge

Take a look at my sketchbook page to get inspired to draw an entire bouquet.

Try to draw this six-rose bouquet on your own. If you really like this six-rose bouquet lesson, check out the twenty-minute video tutorial on my website, www.markkistler.com.

Student examples

Look at these wonderful student drawings of this lesson, and get inspired to practice! Draw! Draw! Draw!

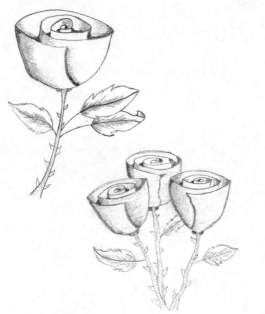

By Tracy Powers

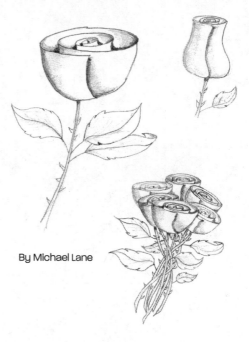

By Michael Lane

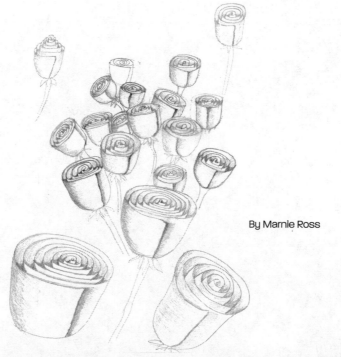

By Marnie Ross

THE CYLINDER

n previous lessons we conquered the sphere and several variations of the sphere. We confidently drew the cube and several variations of the cube. In this lesson we will conquer another building block: the cylinder.

1. Draw two guide dots for your foreshortened circle.

2. Draw a foreshortened circle.

3. Draw the sides of the cylinder with two vertical parallel lines.

4. Curve the bottom of the cylinder, making sure to curve the bottom a bit more than the corresponding curve at the top. This bottom curve uses two key drawing concepts, size and place-ment, simultaneously.

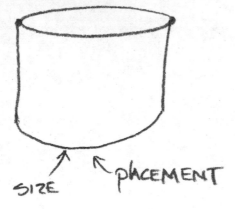

SIZE PLACEMENT

5. To draw the back two cylinders, position the foreshortened circle guide dots above and to the left of the top center of the first cylinder.

6. Complete the foreshortened circle.

7. Draw the sides of the second cylinder. The right side tucks behind the first cylinder, using overlapping, which creates the visual illusion of depth.

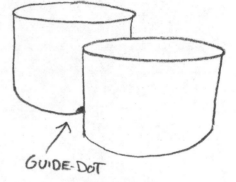

8. Curve the bottom of the second cylinder. Be sure to push this line up and behind the first closer cylinder. The natural tendency is to draw this line connecting to the bottom corner of the first cylinder. I don't know why, but most students do this over and over again. You can see where I put a line placement guide dot on the left side of the near cylinder.

9. Begin the third cylinder with two foreshortened circle guide dots off the top center right of the first cylinder.

10. Draw the foreshortened circle. Notice how my second row of cylinders is a bit smaller than the first cylinder. Complete the third cylinder using overlapping, size, and placement.

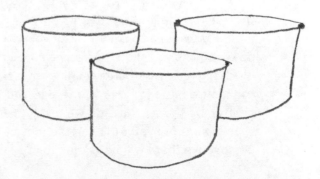

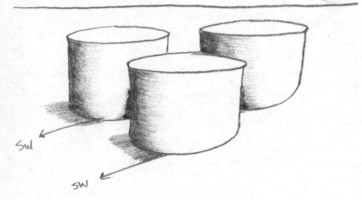

11. Draw the horizon line, and position your light source. I like to begin my shading process by darkening all of the small dark nook and cranny shadows.

12. Complete this drawing of three cylinders. Add cast shadows, opposite your light source, using blended shading. Make sure to use a direction SW guide line to place your cast shadows correctly.

Lesson 10: Bonus Challenge

Okay, now we are ready to start applying our drawing lessons to the real world. Go into your kitchen, and find three soup cans, three soda cans, or three coffee mugs, all of the same size. Arrange the objects on the kitchen table in the same positions that we have just drawn them.

Sit down in a chair in front of your still life. Notice how the tops of the cans are not nearly as foreshortened as we have drawn them. This is because your eye level is much higher than where we imagined it to be in our picture. Push yourself back from the table a bit, and lower your eye level until the tops of the cans match the fore-shortening that we have drawn. Experiment with your eye level, moving your eyes even lower until you can't see the tops of the cans. This is a glimpse of two-point perspective that I will be getting to in a later lesson.

Now, stand up and watch what happens to the foreshortened can tops. They expand; they open up to near full circles depending on where your eye level is.

Understanding the Nine Fundamental Laws of Drawing will give you the skill to draw objects you see in the world around you or that you create in your imagination in any position. Now grab nine cans or mugs (varying sizes are okay). Position them in any way you want on one end of the kitchen table. Sit at the other end of the kitchen table with your sketchbook and pencil. Look at your still life. Draw what you see. Feel free to place a box under your cans to raise them to a higher, more foreshortened perspective.

As you draw what you see, you will recognize the words that you have been learning in these lessons. You will begin to discover how these Nine Fundamental Laws of Drawing truly apply to seeing and drawing the real world in 3-D in your sketchbook.

Here is an important point: In every three-dimensional drawing you create from your imagination or from the real world, you will always apply two or more of the Nine Laws every time, without exception. In this lesson we applied foreshortening, overlapping, placement, size, shading, and shadow.

Photos by Jonathan Little

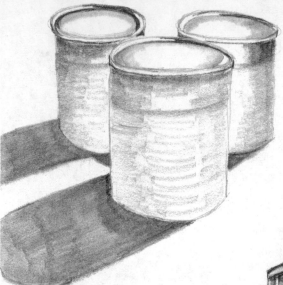

Student examples

Take a look at how student Susan Kozloski explored changing the eye level in her drawings.

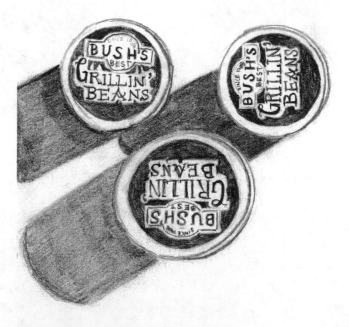

ADVANCED-LEVEL CYLINDERS

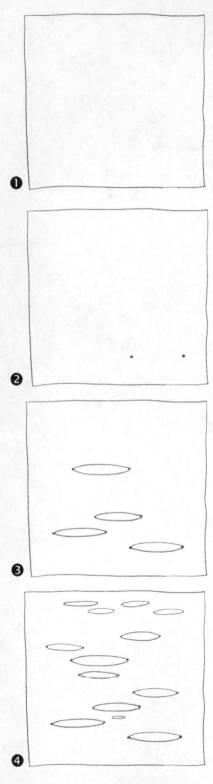

❶

❷

❸

❹

In this lesson I will explore the fun visual effect of drawing multiple cylinders in a cityscape scene. The skills we will be practicing in this drawing are overlapping, foreshortening, blended shading, shadows, and nook and cranny shading. While practicing these skills, we will also push the envelope and expand our understanding of the Nine Fundamental Laws of Drawing. Look at the lesson illustration on the previous page.

Everything looks fine and organized according to the Nine Laws. However, take a closer look at the lowest cylindrical tower. It is much smaller than the surrounding towers, so according to our understanding of the laws, it should appear farther away. Yes? This is an example of how some design laws have more visual power than others. The lowest smaller cylindrical tower appears closer because it is overlapping in front of the other much larger towers. Interesting, isn't it? Overlapping will always trump size.

Here's a mindbender. Look at the two hovering cylinders. The larger one could be closer or farther away. We don't have any reference as to its position. It is not overlapping an object to pull it closer; it is not casting a shadow to indicate that it is directly above or next to an object. In this situation, its size doesn't give us any indication of its position. Now in comparison, look at the smaller hovering cylinder over on the left. Because it is overlapping the other tower and casting a shadow, we can determine it is closer. If I had drawn the center hovering disk a tiny bit in front of a tower, or a tiny bit behind a tower, I would have given the viewer a context of where the disk was, thus eliminating a confusing optical illusion.

Understanding these relationships among the Nine Fundamental Laws of Drawing will help you effectively and confidently resolve positioning problems in your illustrations. We will learn more about how to position your objects to alleviate depth ambiguity when we draw clouds, trees, and two-point perspective cities in later lessons.

Now let's draw!

1. Draw a large picture frame, taking up an entire page of your sketchbook. Sometimes it's fun to place your drawing inside a drawn frame like I did in my sketchbook drawings of the koala, the spheres, and these towers.

2. Using guide dots, draw the first foreshortened circle.

3. Draw more foreshortened circles, some large, some small.

4. As you continue to draw more foreshortened circles, be sure to place some high in the frame.

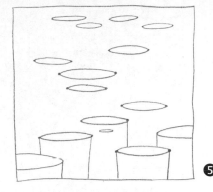

⑤

5. Draw a few more foreshortened circles positioned slightly out of the frame. These peeking towers have a nice visual effect. A few of my students have gone on to illustrate for DC Comics and Marvel Comics. When I've had the privilege of speaking with them over the years, I've always picked their brains for techniques to share with my students. Probably the most valuable tidbit I've heard over and over again is to position objects slightly off frame. For example, when working on *Spiderman* or *The Hulk*, these artists will draw the character moving into the frame or moving out of the frame with just partial views, such as an arm, a shoulder, and an edge of the face.

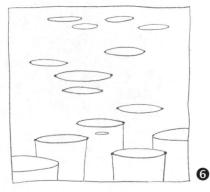

⑥

6. Draw vertical sides down from the lowest foreshortened circle. When you are drawing full scene pictures like this, it is always a good idea to detail in the lowest objects first. Why? Because the lowest objects will be overlapping every other object in the picture. One scenario where you wouldn't necessarily want to draw the lowest objects first is if you are drawing a space scene of planets (think the opening segment of *Star Trek: The Next Generation* or a space scene from *Star Wars*). Another scenario would be if you were drawing a flock of birds in flight. The bird positioned highest in the frame might be drawn larger in size and overlapping other smaller birds lower in the frame. In both scenarios, overlapping still trumps all the other Nine Laws.

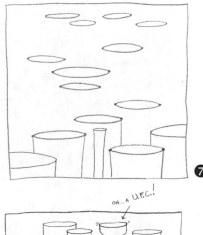

⑦

7. Continue drawing the vertical sides down for the lowest row of towers.

8. Concentrate on overlapping, drawing the important peeking lines down from each and every foreshortened circle.

OH... A U.F.C.!

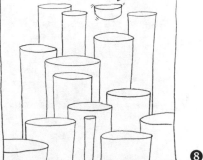

⑧

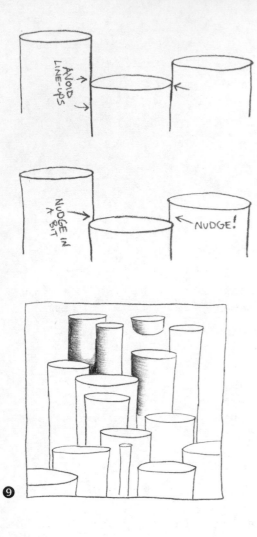

CAUTION: Avoid drawing the sides of two towers lining up like this:

If this happens, go ahead and erase the edge and part of one of the foreshortened circles. Extend the erased foreshortened circle a smidge—just enough to ensure that it is overlapping behind or in front of the other tower. This idea of "offsetting" objects just enough so that the edge lines don't merge is a very small but helpful tip to put in your drawing toolbox.

9. Complete all the towers, moving from the lowest in the frame to the highest.

NOTE: There is one small problem you may encounter as you are drawing the towers. There's a tendency for your drawing hand to smear the lower towers as you move over them to draw the higher towers. A simple practical solution to this is to place a small piece of clean scratch paper over the completed portion of your drawing, place your hand on the scratch paper, and draw the next row. Then pick up the scratch paper and reposition it higher. Do not push the scratch paper with your drawing hand to reposition it. I use this scratch-paper-shielding technique in every pencil and ink illustration I create.

Begin your nook and cranny shadows at the top, and work your way down using your scratch-paper shielding. You want to avoid smearing your drawing during this detail phase. I can't tell you how many nearly complete thirty-hour illustrations I have totally smeared by drawing a final detail near the top of the frame. Avoid smearing!

10. Complete the blended shading on the remaining towers.

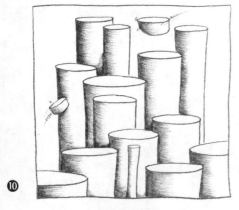

Lesson 11: Bonus Challenge

After that "towering success" (pun fully intended), let's reverse the exercise to practice foreshortened circles, size, placement, shading, shadow, and thickness. Let's draw a field of holes. Because these foreshortened circles are on "top" of the ground, the thickness of these holes will be at the top of the foreshortened circle. This is a fun challenge. Enjoy!

Student examples

Look at how these students stretched their imagination and drawing skill.

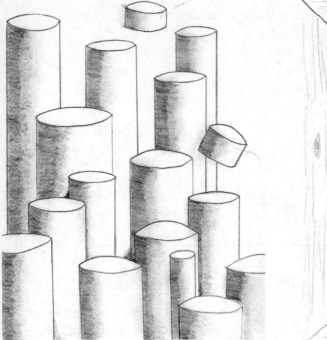

By Tracy Powers

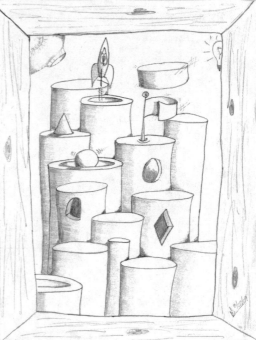

By Michael Lane

By Ann Nelson

CONSTRUCTING
WITH CUBES

*L*et's recap where we are in this thirty-day journey. You've mastered drawing spheres, multiple spheres, and stacked spheres all with blended shading. You have learned how to draw the cube, cube variations, multiple layered–cube buildings, and towers of tables and, most importantly, how to apply the drawing compass directions: northwest, southwest, northeast, and southeast. You will now use these skills to draw more real-world objects. In this chapter, you'll start by drawing a house; then you'll draw a mailbox.

1. Draw a cube very, very lightly.

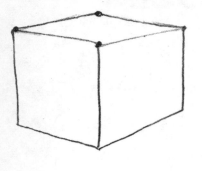

2. Draw a guide dot in the middle of the bottom line of the cube, on the right side.

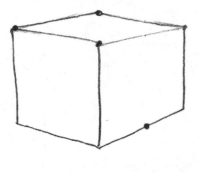

3. Draw a very light vertical line up from this guide dot. This will be our guide to creating the roof of the house.

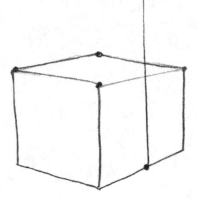

4. Connect the front slopes of the roof. Notice how the near slope is longer than the far side. This is a perfect example of how size and placement create depth. The near part of the roof is longer to make it appear larger and to create the illusion that it is closer to your eye.

5. Using the lines you have already drawn as a guide, draw the top of the roof, being very careful not to angle this line too high (example 5b below). This is a problem many students initially have with this lesson. To avoid this, consciously and specifically refer back to your first lines drawn in direction northwest.

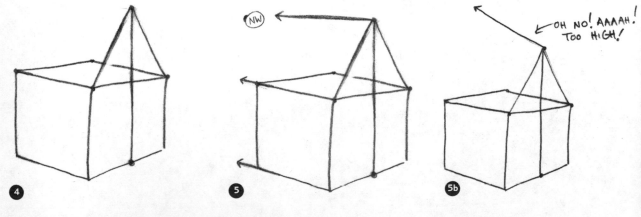

6. Draw the far side of the roof by matching the slant of the front edge. When I draw houses, I have found that slanting the far edge of the roof a little less than the near edge helps the illusion.

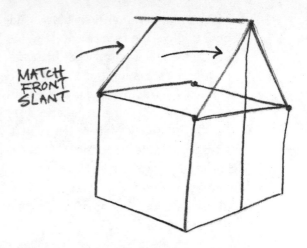

MATCH FRONT SLANT

This is just a peek at the visual illusion of two-point perspective. We'll do more with the law of perspective in later chapters. I just wanted to whet your appetite for new, challenging drawing lessons!

Look at how fascinating it is to see the house lined up with drawing compass directions NW and NE and to see how they merge into a disappearing vanishing point on either side of the object. In fact, you have already been effectively using this advanced two-point-perspective science in your three-dimensional drawings without even knowing it!

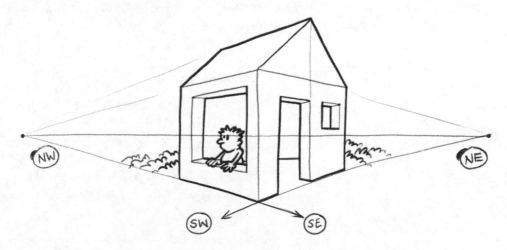

Now, take a moment to think about this: You have *already* been effectively using this advanced two-point-perspective science in your three-dimensional drawings *without even knowing it*! Surprise, surprise!

A good analogy to this idea is that I can type on my laptop, yet not have a clue as to the mechanics of how a computer actually works. You can safely drive a car without understanding how the engine works. Similarly, you can (and have!) successfully learned how to draw fundamental shapes without knowing the science behind it. I'm not saying that you shouldn't learn the science of vanishing-point-perspective drawing, because you should, and you will in later chapters. But what I am saying is that too often, in too many classrooms and in too many how-to-draw books, the immediate introduction of excessive, tedious drawing information can

severely hinder or entirely block students from experiencing the initial fun of learning how to draw the fundamentals. When information-overload anxiety hits beginning students, they naturally get frustrated. They experience failure and accept a completely false assumption that they are void of talent and therefore do not have the ability to learn how to draw. The truth is that learning how to draw has *nothing* to do with talent. You have experienced this firsthand with these lessons.

During thirty years of teaching drawing, I have learned that the best way to introduce students to the thrill of drawing in 3-D is by first offering IMMEDIATE success. Immediate success ignites delight, enthusiasm, and MORE interest. More interest inspires more practice. More practice builds CONFIDENCE. And confidence perpetuates a student's desire to learn even more. I call this the "self-perpetuating learning success cycle."

What we have seen in these lessons is that drawing absolutely is a learnable skill. Moreover, learning to draw can dramatically increase your communication skills—which can in turn have an extraordinary effect on your life. I've personally witnessed the effect it has had on many of my former students, who have fulfilled their individual potential as remarkably creative teachers, engineers, scientists, politicians, lawyers, doctors, farmers, NASA Space Shuttle engineers, and yes, top artists and animators.

7. Draw the horizon line above the house, and position your light source. Clean up your drawing by erasing the extra guide lines.

8. Using the lines you have already drawn in direction NW as reference, sketch in light guide lines on the roof for shingles. Draw the direction SW guide line on the ground to add the cast shadow. Darken in the undershadow along the base of the roof. The darker you make it, the more you will recess the wall under the roof, pushing it deeper in the picture.

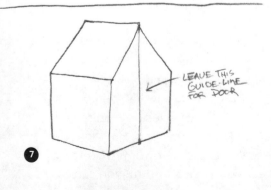

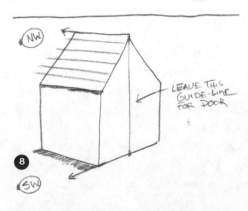

9. Complete the simple house with shingles, drawing the near shingles larger and reducing the shingles in size as they move toward the far side of the roof. Draw the windows, keeping your lines parallel to the outer wall edges. Same idea applies to the door. Draw the vertical lines of the door matching the vertical lines of the center and right side of the house. I've scribbled in some shrubs on either side of the house. Go ahead—bushes and shrubs are fun details to add.

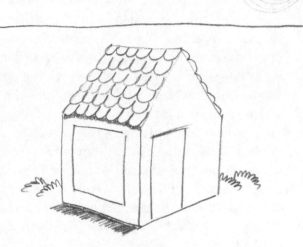

10. Add thickness to the window and door. Complete the drawing with shading.

Nice work! You have drawn a nice little house on the prairie.

Lesson 12: Bonus Challenge

By Michele Proos

Understanding how fundamental shapes, such as the cube and the sphere, can be transformed into real-world objects is one of the main goals of this book. Take a look at my student Michele Proos's drawing of the mailbox. Try drawing this mailbox yourself. Begin by transforming a cube into a mailbox. Begin shaping the face of the mailbox on the right or left side of the cube—it's up to you. Again, notice how the near edge of the mailbox face is longer than the far edge. This is another example of how size creates depth. Draw the post and mailbox details. Look at how the dark undershadow pushes the post under the mailbox. Complete your three-dimensional mailbox with more details. These small details—the postal flag, the handle, the street address, and, especially, the texture of wood—finish this drawing nicely.

Consider texture as being the icing on a cake and your drawing as being the cake. Texture adds the visual feel of the surface to your objects: the fur on a cat, the cobblestones on a street, the scales on a fish. Texture is the delicious "flavor" you add to your drawing, the dessert for your eye. A brilliant, inspiring example of texture is Chris Van Allsburg's illustrations in his book *The Z Was Zapped*. Take a look at this book; it will take your breath away!

Student example

Here's a student example of this lesson to inspire you to keep practicing your drawings every day!

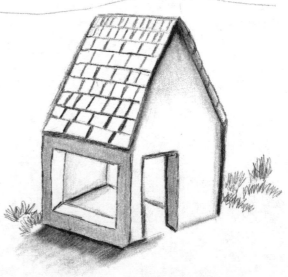

By Kimberly McMichael

ADVANCED-LEVEL HOUSES

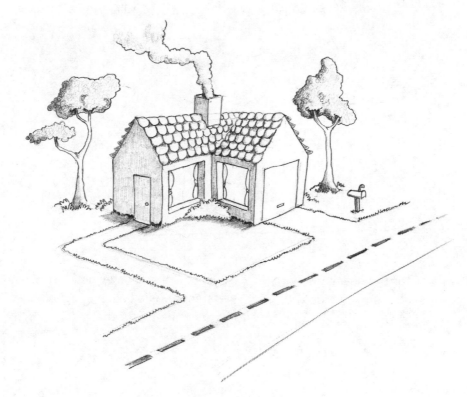

I was initially going to have this advanced-level house as the Bonus Challenge for Lesson 12. However, I realized there was such a high volume of educational content in this drawing that I decided to make it into a full lesson. Doing this allowed me to include an additional house drawing, my favorite "deluxe multiroof house," as the Bonus Challenge. A win-win scenario, I get to wedge another one of my favorite lessons into this book, and you get to learn how to draw more intricate houses.

1. Redraw Lesson 12's simple house up to this step here.

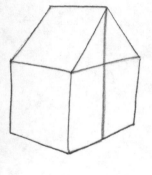

2. Using your direction SW line as the reference angle, draw the ground line for the left section of the house.

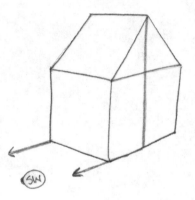

3. Keep your eyes checking the reference lines in direction SW. Now, dash out the next line in direction SW to form the top of the wall.

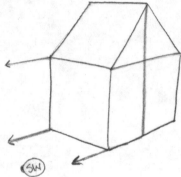

4. Draw the vertical line for the near corner of the house, and draw the bottom left side with a line in direction NW.

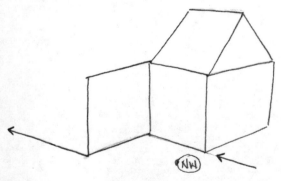

5. That line you have just drawn is now your reference angle line in direction NW. Use this to draw the top of the wall.

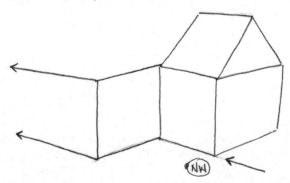

6. Draw the far left vertical wall. Draw a guide dot in the middle of the bottom of the wall.

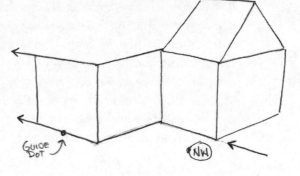

7. Draw the vertical guide line up from your guide dot to position the peak of the roof.

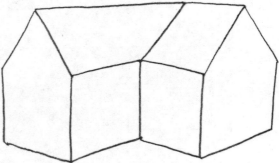

8. Draw the peak of the roof, making sure the near edge is noticeably larger than the back edge. Complete the roof with a line in direction NE. Erase your extra lines.

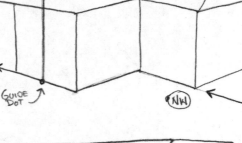

9. Using the lines you have already drawn as reference direction lines NW and NE, lightly draw in guide lines for the shingles. Add the door, windows, and garage. Once again, make sure that each of these detail elements lines up with the direction lines NW, NE, SW, and SE.

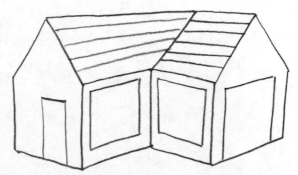

10. Complete your brand-new house! How exciting, but we've got to hustle here—the moving truck is arriving shortly, and we still need to install the new carpeting. Draw in the shading, shadows, and very dark undershadows under the eaves. The sidewalk and driveway are drawn by strictly following your direction guide lines! Look at how much faith I have in you! This is a very difficult element, and I've thrown you out there on your own with no safety guide lines! You are well on your way to drawing houses with only a few guide lines. You are way out on an independent limb here, so you might as well sketch in a few trees and shrubs, and (why not?) let's recycle our good ole mailbox from Lesson 12.

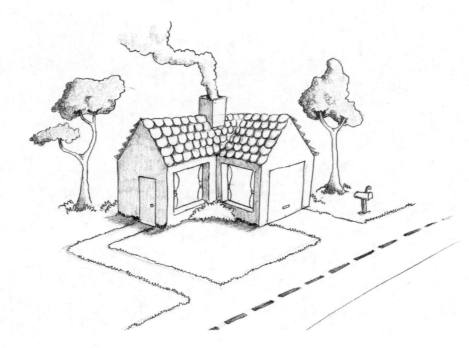

Lesson 13: Bonus Challenge

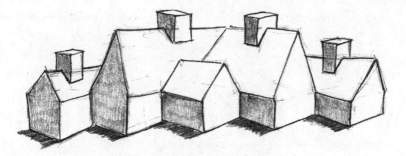

Before you try to draw this on your own, which I know you will successfully do in short order, I want you to trace this building three times. "What!" you exclaim in shock and horror. "Trace? But that's cheating!" No, no, no, I do not agree. For thirty years I have gotten flack for always encouraging my students to trace pictures. I encourage them to trace pictures from superhero comic books, Sunday comics, magazine photos of faces, hands, feet, horses, trees, and flowers. Tracing is a wonderful way to really understand how so many lines, angles, curves, and shapes fit together to form an image. Think of any of the great artists, painters, or sculptors of the Renaissance—Rafael, Leonardo, Michelangelo—they all traced pictures to help them learn how to draw. I have discussed this age-old art education question with my colleagues at Disney, Pixar, and DreamWorks PDI. Each one of them unhesitatingly responded that tracing the drawings of master illustrators helped them truly learn how to draw during their high school and art college years.

By Kimberly McMichael

Lesson 13: Bonus Challenge 2

For this challenge, visit my website, www.markkistler.com, and click on the video tutorial entitled "Deluxe House Level 2." (Be ready to push pause on your computer screen a lot as you draw.)

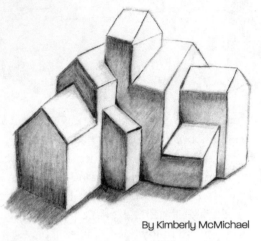

By Kimberly McMichael

Student examples

Look at a few student drawings, and compare their different unique style with yours. You each followed the same lesson but had slightly different results. Each of you is in the process of defining your own unique style and your own unique way of interpreting these lessons and the visual world around you.

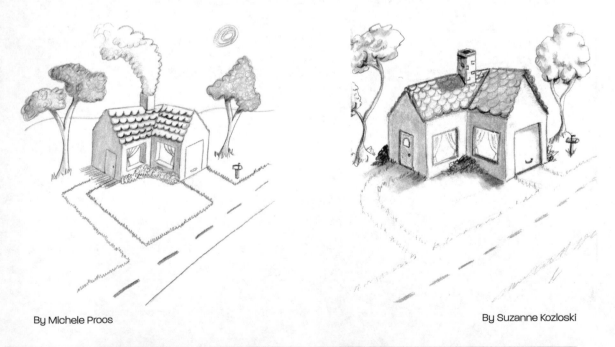

By Michele Proos

By Suzanne Kozloski

THE LILY

*T*oday, as a reward to yourself for doing such a wonderful job of drawing diffi-cult houses, enjoy drawing these flowing graceful lilies. This lesson will highlight a simple yet important line: the S curve. After you finish this lesson, I want you to take a walk around your home (or wherever you happen to be). I want you to carry your sketchbook and write down/sketch six objects that have S curves in them (tree trunks, window drapes, flower stems, a baby's ear, a cat's tail). You will be surprised how easy they are to spot once you open your artist's eye. This exercise will help you become aware of how important S lines are to our aesthetic world.

1. Begin the first lily with a graceful S curve.

2. Tuck another smaller S curve behind the first one.

3. Transferring what you learned from drawing all those foreshortened cylinders in the earlier lesson, draw an open fore-shortened circle to create a petal.

4. Draw the pointed lip of the petal. Draw the bell of the flower by tapering the sides down. Tapering is another one of those very important ideas that you will start to notice everywhere now that you are aware of it. Your child's arm tapers from the shoulder to the elbow and from the elbow to the wrist. A tree trunk tapers from its base to its branches. Your goldfish's fins, your living room furniture, that martini glass in your hand, all consist of tapered lines.

5. Draw the curved bottom of the bell. Here we're using the concept of contour. Curving contour lines define the shape and give it volume (contour lines will be described in greater detail in the next chapter). The near part of the bell is curved lower on the paper. Draw the seed pod in the center of the bell.

6. Draw more S curves to create the tops of the leaves.

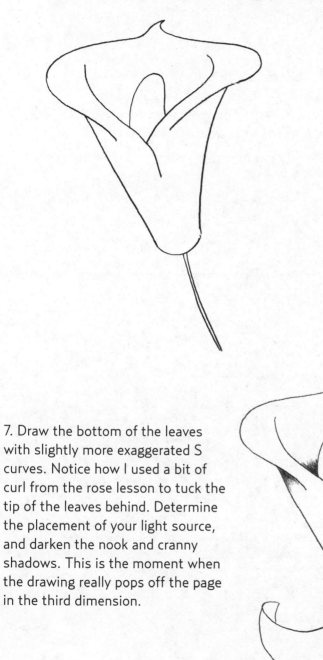

7. Draw the bottom of the leaves with slightly more exaggerated S curves. Notice how I used a bit of curl from the rose lesson to tuck the tip of the leaves behind. Determine the placement of your light source, and darken the nook and cranny shadows. This is the moment when the drawing really pops off the page in the third dimension.

FINISH THE LEAVES WITH "S" CURVES.

DARK NOOK & CRANNIE SHADING!

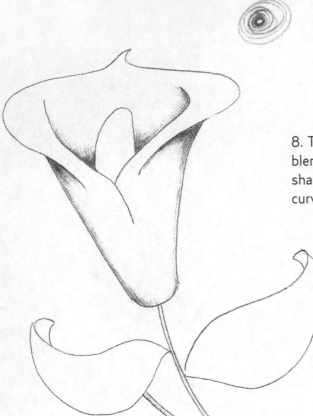

8. To complete the shading, use your blending Stomp to gradually blend the shading from dark to light across the curved smooth surface of the flower.

9. Add a few more lilies to create a delightful bouquet! Hey, here's a fun idea: Scan your drawing of these lilies, and e-mail the flowers to all your friends! E-mail me a copy too (www.markkistler.com).

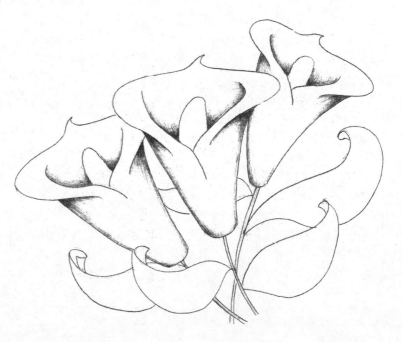

Lesson 14: Bonus Challenge

Take a look at this simple variation of the rose and the lily. Draw a few of these, and then create a dozen of your very own unique variations.

Note: A book that you must get your hands on is *Freaky Flora* by Michel Gagné. Incredible drawings, inspiring creativity, wonderful shading, I absolutely love this artist's work. Also take a look at the amazing flowers in Graeme Base's *Animalia*. They're just phenomenal.

Lesson 14: Bonus Challenge 2

Take a stroll around your home, garden, or office with your sketchbook, and note/sketch where you see S curves and tapered lines in at least six places/objects.

Student examples

I enjoyed these student examples so much. Take a look and keep inspired to draw, draw, draw every day!

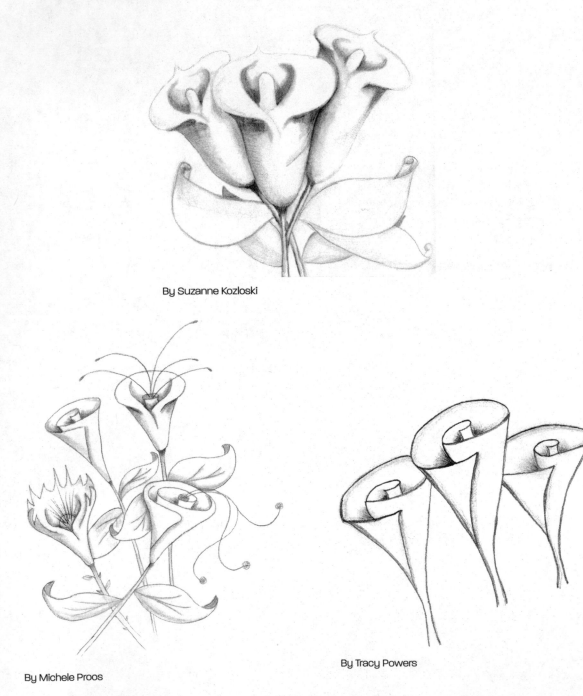

By Suzanne Kozloski

By Michele Proos

By Tracy Powers

CONTOUR TUBES

To effectively draw curving tubular objects, such as trains, planes, automobiles, trees, people, or even clouds, you need to master contour lines. Contour lines are especially important when you are drawing the human figure. Arms, legs, fingers, toes, and, well, just about every part of the human figure involves the use of contour lines.

Contour lines wrap around a curved object. They give an object volume and depth and define an object's position. Is the object moving away from or toward your eye? Is the object bending up or twisting down? Does the object have wrinkles, cracks, or a specific texture? Contour lines will answer these questions and many more by giving your eye visual clues regarding how to perceive the object as a three-dimensional shape on your paper. In this lesson we will practice controlling the direction of a tube with contour lines.

By Ward Makielski

1. Draw a Drawing Direction Reference Cube.

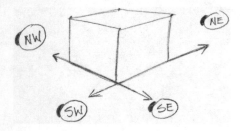

2. Using the drawing compass direction NE as a reference, draw a light guide line in direction NE.

3. Draw a guide dot to position the foreshortened circle end of the tube.

4. Draw the vertical foreshortened circle end of the tube.

5. Using the line you have already drawn in direction NE as reference, draw the thickness of the tube. Draw this line from the very top edge of the vertical foreshortened circle. Notice in my illustration how this line is slanted just a tad bit more than the bottom line, making the tube taper as it recedes away from your eye. This is an application of the drawing law of size to the tube. These lines will eventually merge together at a distant vanishing point, which we will get to later in the book.

6. Curve the far end of the tube a bit more than the near edge. The law of size not only shrinks things as they move away from your eye; it also distorts images. Thus, the far edge is more curved than the near edge.

7. Begin drawing the near contour lines on the surface of the tube. Notice how these contour lines curve a bit more as they move away from your eye.

8. Complete the contour lines. Continue to curve them more as they move away from your eye.

9. To create the illusion of a hollow tube, draw the inside contour lines, following the outside far edge of the initial foreshortened circle. Yes, even these internal contour lines need to curve more as they move away from your eye.

10. Determine the position of your light source. Using the curve of your interior contour lines, add shading to the inside of the tube.

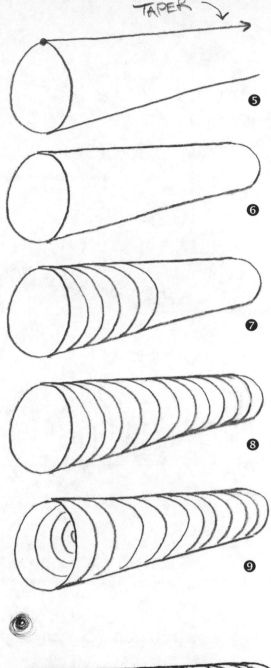

TAPER

⑤

⑥

⑦

⑧

⑨

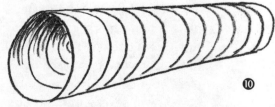

⑩

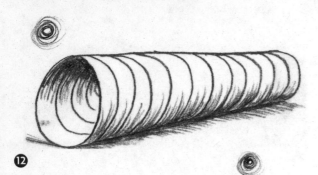

11. Draw the cast shadow with a guide line in direction SE.

12. Shade the tube with curving contour lines. This technique of shading with contour lines is an excellent way to create texture and three-dimensional shape.

13. Draw the second tube for this lesson with a guide line in direction NW. Draw a guide dot for the vertical foreshortened circle. Draw the vertical foreshortened circle. Draw the thickness of the tube receding away in direction NE. Draw the contour lines on the outside of the tube. Voilà! You just defined tube number two as facing in the opposite direction of tube number one. Contour lines are very powerful in defining an object's direction and position on the paper. To shade this second tube, draw your light source top right and shade opposite.

Lesson 15: Bonus Challenge

Try this visual experiment: Get ahold of an empty paper towel cardboard roll. Using a black Sharpie marker, draw a row of dots about an inch apart down one side of the tube, from opening to opening. It will look like a row of rivets or a zipper. Now, carefully draw a line from each dot around the tube back to the same dot. It's easier to place your pen on the dot and just roll the tube away from you. Repeat this until you have drawn several rings around the tube.

Hold the tube horizontally in front of your eye at arm's length. All the rings you have drawn will appear to be vertical lines. Slowly swivel one end toward your eye, just a bit. Notice how the vertical lines now are distorted into contour lines. Experiment with this tube a bit, twisting it back and forth. Now, bend the tube in half and do the same thing . . . interesting, right? See how the contour lines are now climbing across the tube in different directions? Take a look at the long bending tube at the bottom of my sketch page below. Notice how contour lines control the direction of this tube.

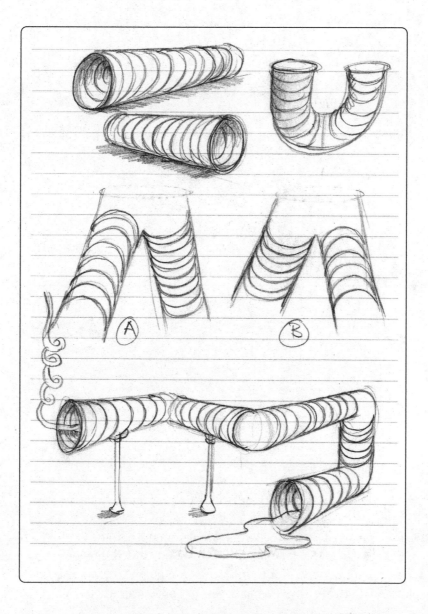

1. Now, I'm going to demonstrate the push-and-pull power of contour lines. For the first image, I want to draw the left leg to make it appear to be moving toward you and the right leg to appear to be moving away. Look at my examples below, and draw this important exercise.

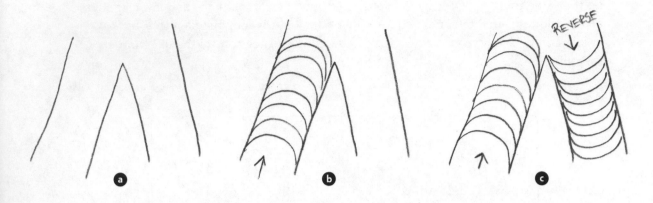

2. We are now going to reverse the contour lines on the second identical image. With just contour lines, we will create the 3-D illusion that the image is moving in the opposite direction. Draw this contour tube in your sketchbook.

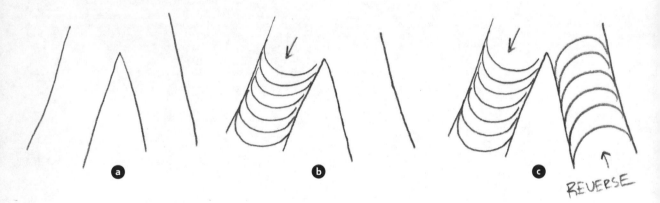

Lesson 15: Bonus Challenge 2

I always enjoy the Michelin Man tire commercials. This animated stacked tire-man resembles more of a snowman/soft-serve ice cream creature than tires to me. However, this Michelin Man is an excellent example of contour lines defining shape and direction. Google "Michelin Man" and take a look at this tire fellow. With this image in mind, let's create our own Contour Kid. We are going to draw two Contour Kids side by side to illustrate the dynamic power of contour lines.

1. Lightly sketch the head and torsos of two Contour Kids.

2. Sketch in the legs, and try to draw these initial details as identically as possible, just reversing the foreshortened circle "stepping toward you" leg.

3. Sketch in identical arms on both Contour Kids; just reverse the foreshortened circle from the left arm to the right arm.

4. Have fun drawing the arms swinging out and the legs stepping. Draw the curving contour lines going in opposite directions on the arms and legs to create totally different illusions of push and pull in your drawing.

You can spend days experimenting with contour lines. Take a look at a few student examples.

Student examples

By Suzanne Kozloski

By Tracy Powers

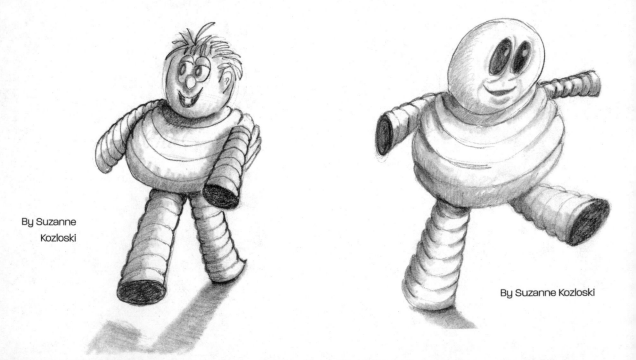

By Suzanne
Kozloski

By Suzanne Kozloski

THE WAVE

A fun way to apply the contour lines you just learned about in Lesson 15 is to draw a wave of water in 3-D. As a kid growing up in Southern California, ocean waves were a large part of my life. Whenever I draw this lesson, I'm brought back to my teenage years when I would bodysurf enormous waves and see porpoises swimming in the waves right in front of me. This wave lesson is a good example of seeing and drawing contour lines in the real world.

1. Let's begin by sketching the Drawing Direction Reference Cube to see clearly the drawing direction compass angles.

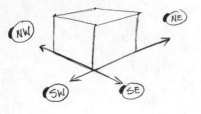

2. Draw a light guide line in direction NW.

3. Sketch in a foreshortened circle to begin shaping in the curl of the wave.

4. Taper the top of the curl of the wave with a light guide line, again in direction NW. The drawing law of size is applied here to make the larger end of the curl look closer.

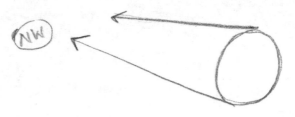

5. Draw a guide dot to establish the near point of the curl.

6. Follow the curvature of the curl to create a "flowing" line. Draw from the guide dot, up the foreshortened circle edge, and down the back side; then shoot off in drawing direction SW. Be sure to use your Drawing Direction Reference Cube!

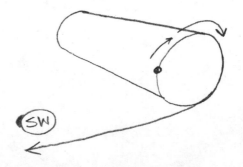

7. Okay, now this is going to get very interesting. We want to create the illusion of water curling over the wave lip. Let's do this with a guide line in direction NW. Erase your extra guide lines and the Drawing Direction Reference Cube.

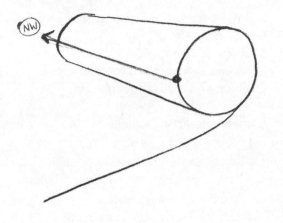

8. Start drawing the frothy foam along the NW guide line.

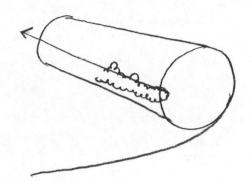

9. Draw the foam all the way back. Notice how I expand the frothy foaming mist toward the back. This is because real "tubing" waves collapse very quickly, peeling across the front (at least all the waves in Southern California did!).

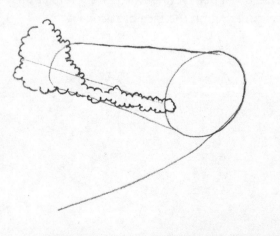

10. Begin "shaping" the wave with flowing contour lines curving down from the top. Curve these more and more as they recede back into the picture.

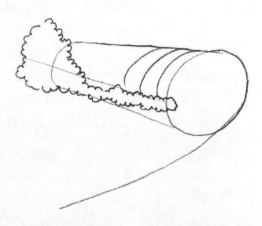

11. Complete all the curving contour lines for this top lip portion.

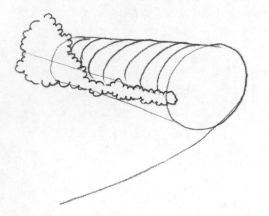

12. Let's define the wave foam by darkening in the nooks and crannies behind the foam.

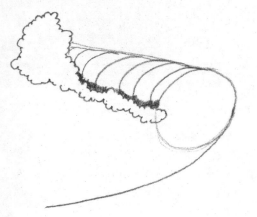

NOTE: At this point I ask myself, do I continue with all the contour lines, do I sharpen up the area, or do I begin a bit of shading? This is part of the joy of drawing, the creative part of illustrating. The following steps, which we have developed over the last few lessons, do not have to be strictly followed:

Lightly sketch, shape, and mold the object.
Refine and define.
Shade and shadow.
Sharpen edges and add focused detail.
Clean up and erase extra lines.

Sometimes, actually most of the time when I'm not teaching but just drawing a personal sketch, I'll completely ignore this sequence and just work from inspiration and feeling. This is such an exciting point to reach in your drawing skill. This is the transition from being a student, following steps from your instructor, to understanding the process so completely that you confidently and comfortably begin to drift ahead on your own.

13. Continue the drawing with more detail in the foot of the wave. Draw more flowing contour lines.

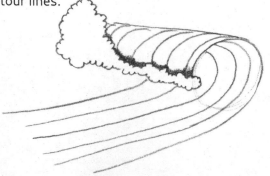

14. Draw several guide lines in direction NW. These will help you draw the light reflections shimmering on the face of the wave.

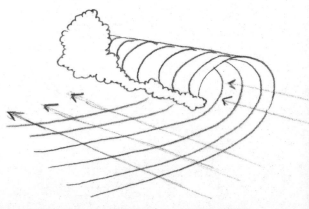

15. Outline the wave with a dark, defined line. Darken in the shadow under the wave lip. Be sure to blend it down, lighter and lighter toward the reflection.

Complete the illustration by adding action lines. Action lines are fantastically fun to draw and enable your viewers to visually engage in your art. Look at how my action lines are flowing in the direction the wave is moving. Draw these flowing lines on your wave.

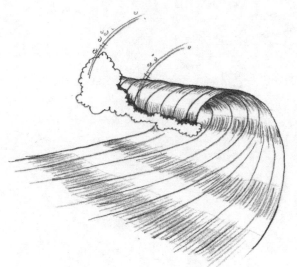

Lesson 16: Bonus Challenge

Let's take the skills we've acquired from drawing a wave and apply them to another fun drawing: the whoosh cloud. Practice drawing overlapping foam, dark recess (nook and cranny) shadows, and action lines. Feel free to draw this one with me online at www.markkistler.com; click on "Drawing Lessons."

Student examples

Take a look at these students' drawings of the wave lesson. Seeing other students' work helps build your motivation to draw every day, right?

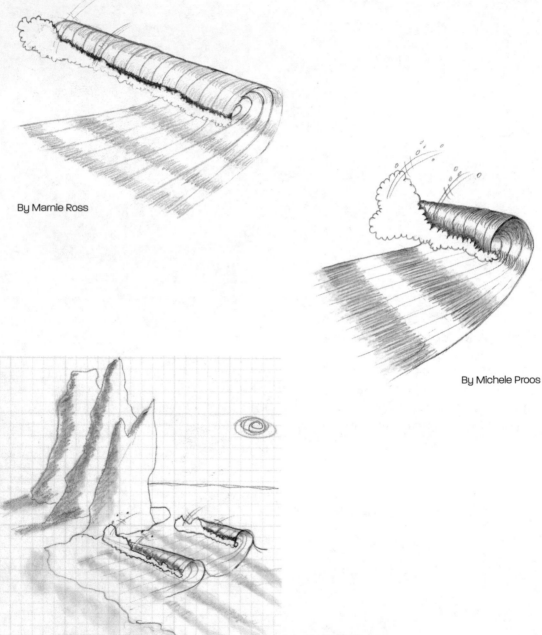

By Marnie Ross

By Michele Proos

By Marcia Jagger

RIPPLING FLAGS

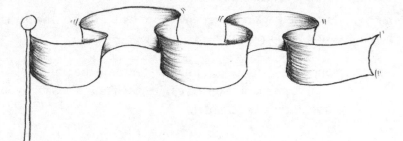

*T*hese next two lessons will be great for learning how to draw flags, scrolls, curtains, clothing, furniture coverings, etc. Interior decorators, theater art directors, and fashion designers all must master the skill of drawing flowing fabric.

This lesson is a good practice exercise for applying many of the Nine Fundamental Laws of Drawing. These laws all work together to create the illusion of depth, of visual push and pull in the rippling flag drawing.

Foreshortening: The top edge of the flag is distorted using foreshortened circles.

Overlapping: Parts of the flag fold in front of other parts, using overlapping to create the illusion of near and far.

Size: Parts of the flag are drawn larger than other parts, creating the visual pop-out of depth.

Shading: Parts of the flag are drawn darker on the surfaces facing away from the light source, creating the feel of depth.

Placement: Parts of the flag are placed lower on the surface of the paper than other parts, creating the illusion of near and far.

If you are a scrapbooker, I'm sure you immediately saw the potential of this flag lesson in enhancing your scrapbook pages, yes? If you like this lesson, you are going to love the scroll lesson in the next chapter.

1. Begin with a tall vertical flagpole.

2. Draw three-quarters of a foreshortened circle. Keep the shape squished.

3. Picture three foreshortened cylinders next to each other like I have illustrated below. Now, draw the top of the flag by following the top edges of these cylinders.

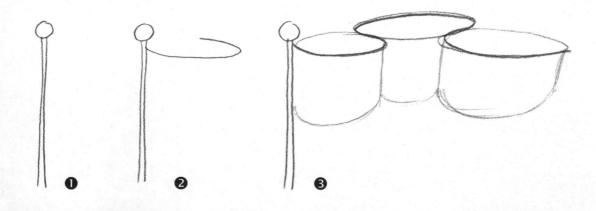

4. Repeat this several times, extending the top edge of the flag.

5. Draw all the near thickness lines first, with vertical lines drawn down from each edge.

6. Draw each of the back thickness lines, making sure they disappear behind the flag. The small disappearing lines define the overlapping shape of the flag. These are the most important detail lines when you draw a flag. Without these lines, your drawing will visually collapse, so carefully double-check that you have not missed any of the back edges.

7. Draw the bottom edges, curving toward your eye. Ignore the back spaces for now. Remember to curve these even more than you think you need to.

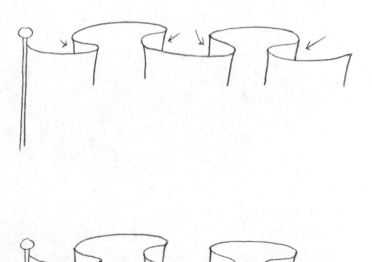

8. Before you draw the back thickness lines, think of the visual logic of this rippling flag. You are creating the illusion that the flag is folding away from your eye, so the visual logic dictates that the back thickness must be pushed away from your eye. We accomplish this by using placement: Objects in the foreground are drawn lower, whereas objects in the background are drawn higher. When you are learning to draw in 3-D, a very simple rule applies: If it looks wrong, it is wrong. (Now, I'm not saying that Picasso's distorted faces are drawn "incorrectly," as Picasso was not intending to paint in 3-D. You are learning to draw in 3-D, so specific laws of creating depth apply.)

9. To complete the rippling flag, add shading and nook and cranny shadows.

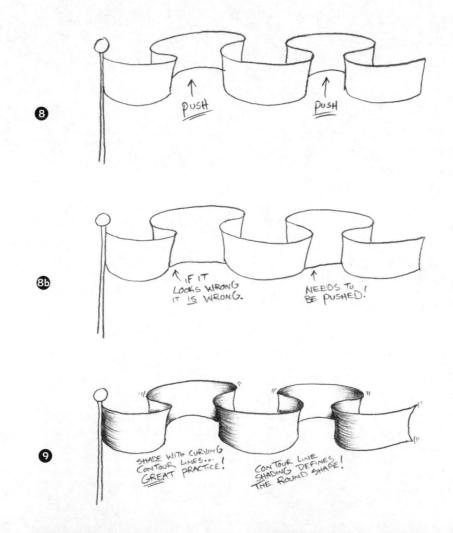

Lesson 17: Bonus Challenge

You have learned everything you need to draw a wonderfully long rippling flag. Look in your sketchbook, and review the cylinder lessons, the rose lesson, and this lesson. Take a moment, look at the page from my sketchbook below, put it all together, and enjoy drawing the super long flag. You can do this! Notice how I have tapered and curved all of the flag thickness lines inward. This will give your flags a bit more character and bring them to life on the page. See?

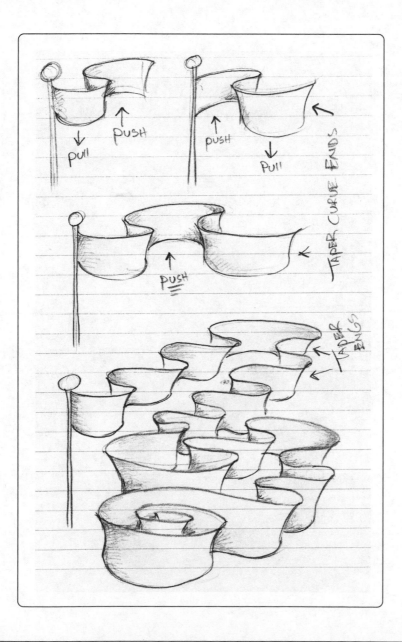

Lesson 17: Bonus Challenge 2

Still not enough flag madness for you? Here are two fun illustrations drawn by two of my students while watching my online video tutorial.

Student examples

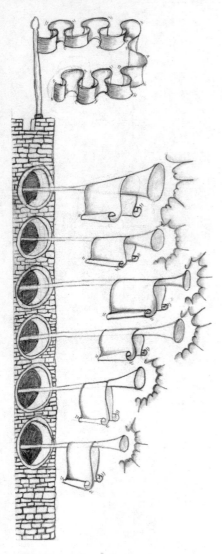

By Michele Proos

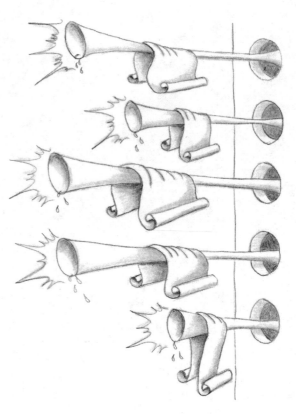

By Marnie Ross

THE SCROLL

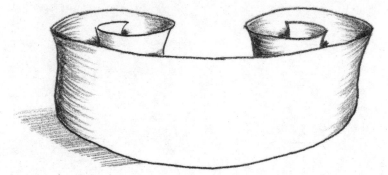

s you can see by the illustration on the previous page, this is most definitely one of my favorite lessons. I guarantee you are going to love this lesson so much that you are going to start doodling scrolls on just about everything from now on— your office memos, grocery lists, to-do lists, and more!

In this lesson I will emphasize the drawing concept of "bonus detail." I want to encourage you to use these drawing lessons as starting points for much more elaborate, detailed drawings that you create on your own. This scroll lesson is an advanced version of the rippling flag lesson after I've added bonus details to it.

1. Very lightly sketch two cylinders a bit apart from each other.

2. Using these two cylinders as forming spools for our scroll, connect the near edge of the ribbon with curved lines. Curve these lines even more than you think you need to. This is using which two important drawing laws? Placement and size!

3. Erase your extra lines, and spiral in the scroll following a foreshortened pattern much like we did on the rose drawing, yes? You see, everything I teach you in this book is transferable information.

4. Draw all the peeking thickness lines tucked behind the near edges of the scroll. These tiny detail thickness lines are the most important lines in the entire drawing. If you forget one of these, or if you don't line each up carefully with the very edge of the foreshortened curve, your drawing will collapse. (However, I'm sure you will not have to worry about this fate, because you will never forget any of your tucked thickness lines, right?)

5. Position your light source in the top right corner. Use a light guide line in direction SW to draw the cast shadow next to the left side of the scroll. Using curved contour lines, shade all the surfaces opposite the light position. You see how I've pulled the light position toward your eye, in front of the drawing. Notice how I've shaded a bit on the right side of the scroll as well. Experiment with your light position. In your practice drawings, try placing the light source directly overhead, over to the left, or perhaps even below the object. This is a really challenging exercise, but so reward- ing. It will really help you nail down the concept of shading opposite the light source.

Lesson 18: Bonus Challenge

Okay, how wild do you want to get now? How much time do you have left in this drawing session? I can see you easily spending another couple of hours enjoying drawing scrolls. So, draw the scroll below. Combine all the applied drawing concepts of shading, contour, shadow, overlapping, size, placement . . . and you have a very three-dimensional scroll, really alive in that space with depth and volume.

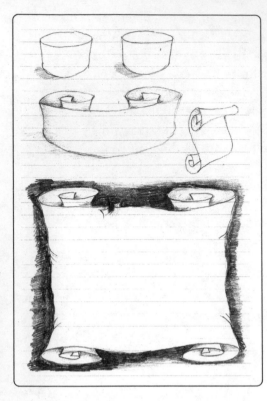

Lesson 18: Bonus Challenge 2

Why stop now? It's only three hours into this drawing session, so let's push on 'til dawn! This is a fun scroll that I've been drawing since watching the old Robin Hood adventure cartoons, where the sheriff's tough guys are hanging the scrolled "Wanted" posters all over town. I also see these cool scrolls on the covers of many children's DVDs and any Renaissance type of fair or celebration. My favorite scroll was actually the rolled carpet character in *Aladdin*. I've spent hours drawing and studying that wonderful carpet.

Take a look at my sketchbook page on the left, and get inspired to draw your own fancy scroll!

Student examples

These student examples are so cool! I'd sure enjoy seeing yours! Why don't you e-mail me some of your drawings (at www.markkistler.com)?

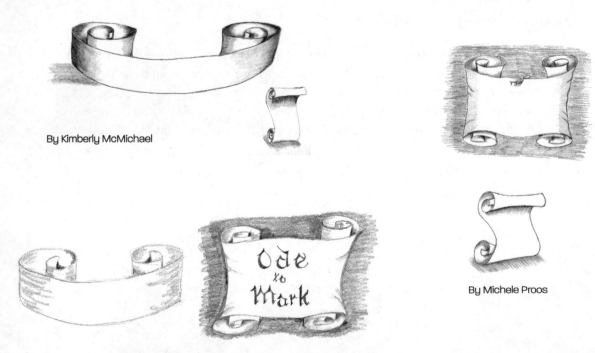

By Kimberly McMichael

By Suzanne Kozloski

By Michele Proos

PYRAMIDS

In this lesson, you will learn how to draw a three-dimensional pyramid. Why a pyramid, you ask? Because I've always wanted to go to Egypt to climb the ancient pyramids. Until that day, I always have my imagination and my sketchbook handy! And so do you! We will be drawing the pyramid by using the following drawing concepts: overlapping, horizon lines, shading, and shadows. This lesson will also help you practice smooth single-value shading. Because the sides of a pyramid are flat, they require one consistent tone for shading, unlike cylinders, flags, and other curved surfaces that require blended shading from dark to light. Now, let's begin.

1. Draw a straight vertical line.

2. Slant the sides of the pyramid down, keeping the angle of the slanted lines identical and keeping the middle line longer.

3. Thinking of your Drawing Direction Reference Cube, draw the bottom of the pyramid in directions NW and NE.

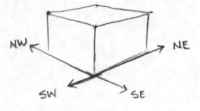

4. Anchor the pyramid to the sand with a horizon line. Position your light source, and draw a guide line in direction SW for your cast shadow.

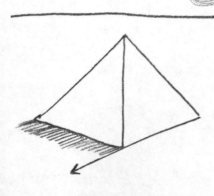

5. Now, add smooth one-tone, single-value shading to the side of the pyramid opposite your light source.

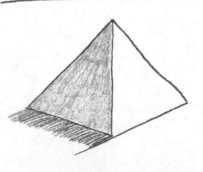

6. You can stop here, and you have a great looking pyramid! You can add the texture of stone blocks, draw some crumbling edges and piles of stone debris, and you have an ancient site. I'm thinking more along the lines of adding doors. Strange? Clever? Sketch in the position of the doors.

7. If the door is on the right, the thickness is on the right; if the door is on the left, the thickness is on the left. Draw the thickness on the right-side door on the right side of the door.

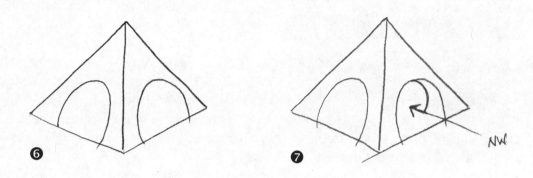

8. Draw the thickness on the left-side door on the left side of the door.

9. Complete the shading on the sides opposite your light source. Remember, this is a flat surface that requires smooth single-tone shading, *not* blending. However, inside the curving door on the right side, I do blend the shading because you always blend shading from dark to light on curved surfaces and you shade with a single value surfaces that are flat and facing away from your light source position.

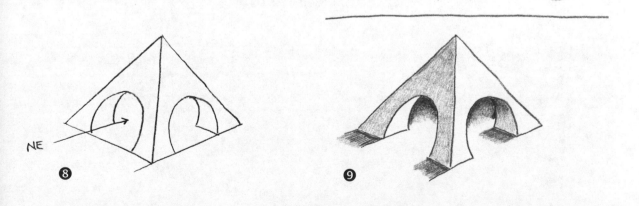

Lesson 19: Bonus Challenge

Depending on how much time you have, draw this wonderful scene of multiple pyramids. Notice how I've drawn one pyramid below the horizon line and a bunch of pyramids far away in the distance, dropping behind the horizon line. A very important thing to notice in this drawing is how the law of overlapping trumps all of the eight other concepts. Look

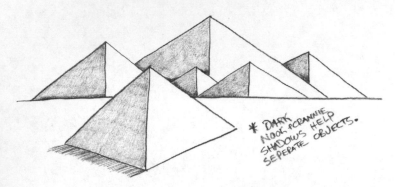

* DARK NOOK & CRANNIE SHADOWS HELP SEPERATE OBJECTS.

at how size is just not a factor in this picture. Usually, in drawings we have created so far, things drawn larger will appear closer and things drawn smaller will appear farther away. However, in this drawing, even though the enormous pyramid dwarfs the smaller group, it still looks farther away, deeper in the picture. Why? Because the power of overlapping. I've drawn all the smaller pyramids overlapping the giant daddy, thus creating the illusion that it is deeper in the scene.

If you are reading this, you have succumbed to the visually tasty dessert these pyramids offer to your eye. Repetition of pattern and design is enormously pleasing to the eye. Take a look at the pyramid variations below, drawn by students just like YOU!

Student examples

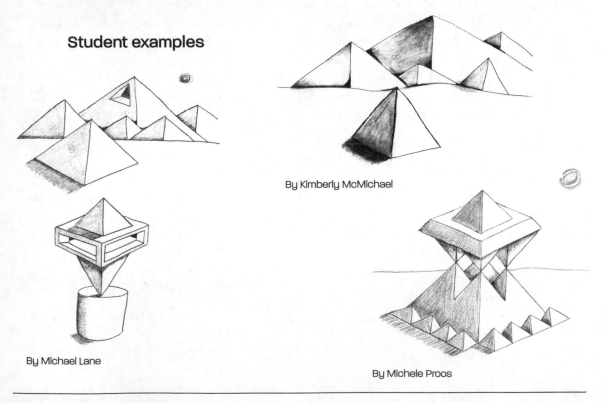

By Kimberly McMichael

By Michael Lane

By Michele Proos

VOLCANOES, CRATERS, AND A CUP OF COFFEE

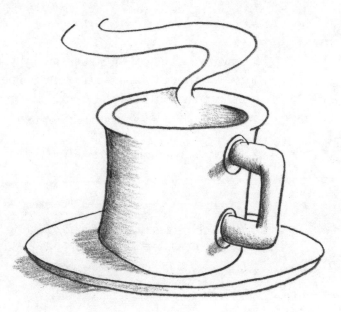

*W*hat do volcanoes, craters, and coffee mugs have in common? This amazing lesson!

Let's stretch our imaginations and apply the foreshortened circle to three completely different objects. With this lesson I want to heighten your awareness of just how many objects in the real world are foreshortened circles. As you draw these three foreshortened objects and the many foreshortened lessons in this book, you will begin to recognize foreshortened objects all around you. Recognizing foreshortening and other laws of drawing in the world around you will help you learn how to draw in 3-D.

As I glance around, I see foreshortened circles everywhere: a water bottle, a coffee mug, a quarter on the carpet next to my computer bag, the top of the fire extinguisher on the wall. Take a look around—how many foreshortened circles do you see? Let's apply foreshortened circles from the real world to our drawing lesson, starting with a volcano.

The Volcano

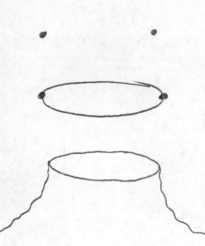

1. Draw two guide dots. I still encourage you to use guide dots even though you are a time-tested pencil warrior deep into Lesson 20 of this book. I still use guide dots after more than thirty years of drawing!

2. Draw a curved foreshortened circle.

3. Slant the sides of the volcano, creating jagged bumpy edges and giving the volcano a feeling of terrain with just a few squiggles.

4. Position your light source, and use blended shading to create a shadow opposite your light source. Do you notice the extended nook and cranny shadow inside the crater?

The Coffee Mug

1. Draw two guide dots, yes . . . again.

2. Draw another curved fore-shortened circle, and complete the cylinder.

3. Remember how we created the lip of the lily blossom? Now, draw a slightly open foreshortened lip at the top of the cylinder.

ERASE

4. Slightly taper the sides of the coffee mug inward. This will add a nice touch of character to your mug.

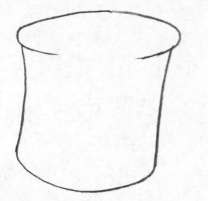

5. Draw a partial foreshortened circle to create the inside thickness.

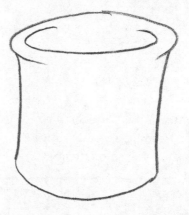

6. Draw a Drawing Direction Reference Cube below this coffee mug. Using this cube as your reference, begin drawing the handle of the coffee mug with guide lines in direction SE.

7. Following the lines you have drawn above, draw two more guide lines in direction SE.

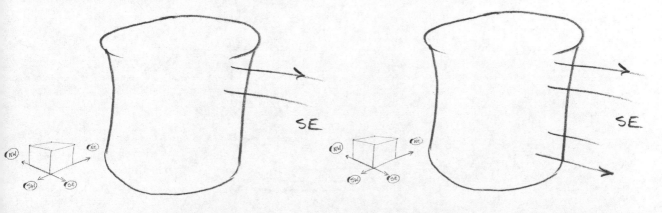

8. Complete the mug handle with vertical lines. Clean up your extra guide lines, and detail in the small overlapping lines. Often a successful 3-D drawing boils down to understanding and controlling these seemingly trivial details. We are going to draw a solid three-dimensional coffee mug that looks like it has substance, volume, and real existence.

9. Draw a cast shadow in a southwest direction, and add a foreshortened plate. Add blended shading.

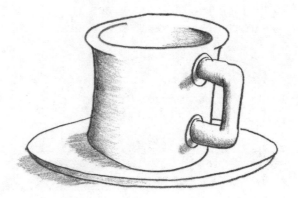

10. Complete this refreshing cup of java by adding an evaporating foreshortened wisp of steam.

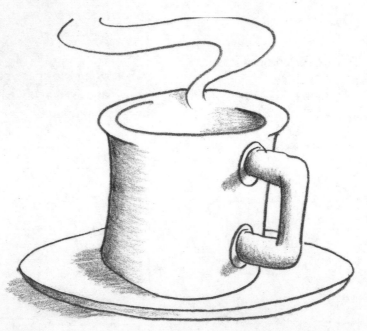

Lesson 20: Bonus Challenge

Check your watch—how long did this lesson take you up to this point? If you are out of time for today, feel good about what you accomplished. You successfully completed the lesson. However, if you really want to feel that you've nailed this concept of applying foreshortened circles, then draw this next challenge!

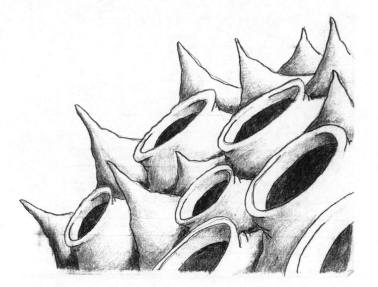

Start with the curving horizon line, and begin sketching the near craters lower on the paper and larger to make them appear much closer to your eye. Draw the distant craters smaller and higher, making them appear farther away. Be sure to overlap the near craters over the far craters. Notice how my dark nook and cranny shadows help separate the craters.

Student examples

Now take a look at how Michele Proos used the coffee mug lesson to draw her real-life "still life." Great job!

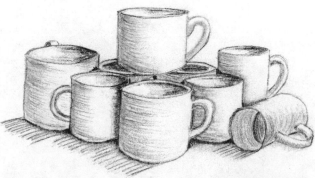

By Michele Proos

Student examples

Look at how these students practiced this lesson in their sketchbooks.

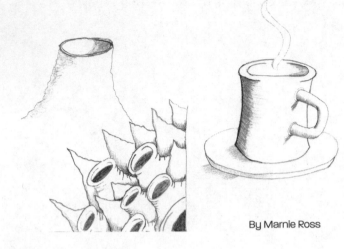

By Marnie Ross

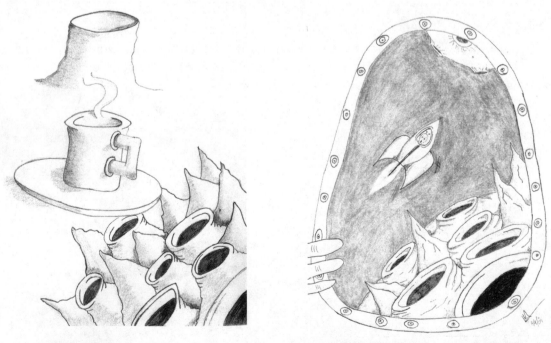

By Tracy Powers

By Michael Lane

TREES

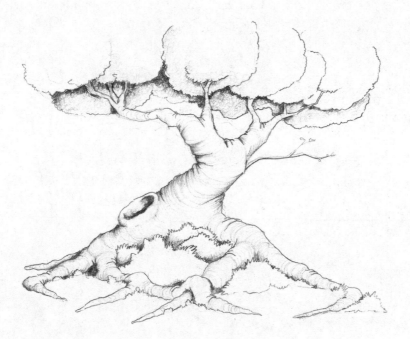

\mathcal{E}ver since I was ten years old, I've been obsessed with drawing trees. I've always been fascinated with the aboveground root canals of the giant fig trees, the gnarly knotholes and deep trunk wood grain on the great oaks, and the whispering, dangling leaves of the weeping willows. In this lesson I will introduce you to the joy of drawing a simple tree with a tapered trunk and overlapping textured clumps of leaves.

Trees surround us, shelter us, warm us, oxygenate us, and provide abundantly for our lives. From the table I'm sitting at and chair I'm sitting on, to the paper you are drawing on, trees are fundamental to our way of life. On my website (www.markkistler.com), I've posted several tree planting organizations that my kids and I are a part of. I encourage you to take a look at these (Google "tree planting organizations") and consider joining one. With this lesson I hope to encourage you to go outside and plant a tree in your yard, your friend's yard, your kid's school, or your place of worship. But first let's draw an inspiring tree!

1. Draw the trunk of the tree tapering out at the bottom.

2. Curve the bottom with a contour line. This will serve as the guide line for the tree's root system.

3. Using the bottom of the contour curve, draw guide lines in drawing directions NE, SE, NW, and SW as I have illustrated.

4. Is this fascinating or what? Draw your tree's root system with long extending tapering tubes out from the trunk, following your drawing direction compass lines. Have you noticed that we use drawing direction lines for just about every object we draw in 3-D?

5. Erase your extra guide lines. Draw the branches tapering smaller and splitting off into smaller branches as I have illustrated here. Notice that I've drawn overlapping wrinkles where the branches split off to identify the overlapping edge more clearly.

6. Sketch a circle to designate where the first cluster of leaves will go.

7. Sketch two more circles behind your first circle: the power of grouping. Essentially, a group of three clumps will look visually more appealing than a single clump.

Most of the time, an odd number of objects in a group will look more pleasing to the eye than an even number. I'm looking out the window right now, and here are some examples of grouping I see from my point of view. The store across the street has a group of three windows to the right of the door and a group of three windows to the left of the door. There is a group of three tree tubs on either side of the store's entrance. Take a look online at famous historical Roman architecture, noticing how many columns are on either side of the entrances or windows. Look at the grouping of windows, arches, and sculptures in historical Renaissance architecture. Grouping is an important art concept that I will discuss in greater detail in our upcoming lessons.

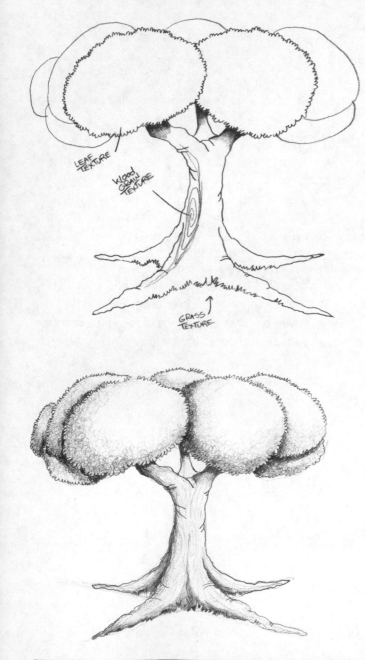

8. As we did in the koala lesson, we are going to draw the surface feel of these leaf clusters. Start by drawing small rows of scribbles as I have illustrated. As you build up more rows and layers of these scribbles, you will create the illusion that these spheres are leaf clusters. Now, draw the textured wood grain with repeated flowing lines running down the trunk. Darken underneath the branches with nook and cranny shadows.

9. Continue to build up the visual effect of leaves, filling in each of your large leaf clump circles with small scribbles. Complete the tree by adding textured shading. Draw long vertical lines to shade the tree trunk and branches. Great work! Nice-looking tree!

Lesson 21: Bonus Challenge

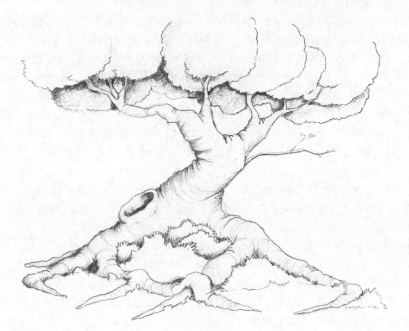

In this bonus challenge, I will teach you how to capture nature's beauty—using a clear clipboard.

Here is what you will need:

- A clear clipboard or any piece of clear solid plastic (I've even used a clear plastic plate to show this technique to friends).
- Two black fine-point Sharpie markers and two black ultrafine-point Sharpies.
- A box of clear overhead "Write-On" transparencies (make sure that the box says, "Write-On," not the ones that are made to be run through a copier).
- One roll of any kind of tape (I prefer white ¾-inch or 1-inch correction whiteout tape, but low adhesive blue painter's tape works fine, too).
- A lightweight portable easel or two cardboard boxes (any kind of cardboard box will do; I have had good success with the white file storage boxes that fold together with a lid).

Using the whiteout tape, secure one sheet of clear plastic Write-On Film to your clear clipboard. One small piece of tape on either side of the transparency will do just fine.

Grab your black Sharpie pens and step outside.

Once outside, find an interesting tree. Stand still, close one eye, and look at the tree through your plastic clipboard. Move around the borders of your clipboard to

frame the entire tree. Place your easel or stack several of the white empty storage boxes at this spot. Hold your plastic frame comfortably while you look through the frame with one eye closed, and trace what you see with your black Sharpie. If you are having trouble holding your clear clipboard up at arm's reach while tracing with the other hand, ask a friend to stand still in front of you for a minute or two. Use her or his shoulder as your easel. Keeping one eye closed, concentrate on the outlines, edges, shapes, and lines. As I've mentioned before, all of history's great artists, Michelangelo, da Vinci, Raphael, Rembrandt, have traced from nature to learn how to really see what they wanted to draw.

If you'd prefer to stay inside, sit at your kitchen table with a plant or a flower in a vase in front of you. Experiment by placing the flower very close to your clipboard and then moving it far away. As you draw these images with one eye closed, notice how our drawing laws (overlapping, shading, shadow, and horizon lines) come to life.

This clear clipboard is an idea I dreamed up twenty-five years ago when I was drawing a picture of my friend's pet collie. I was having a difficult time capturing the soft expressive eyes and the wonderful flow of the collie fur. (This was way before digital pictures instantly zapped from your cell phone to your printer, and all I had handy was a wide plastic straight edge.) I remember doing this technique directly on the straight edge. I was able to draw only a sliver of the collie due to the width of the straight edge, but it was enough for me to solve the problem. At that time I had no way to quickly transfer the image to paper, so I just wiped it off.

Years later, my friend Michael Schmid created a wonderful exercise for his art classroom. He constructed a standing framed four-foot-by-four-foot clear plastic partition. He would have students sit on either side with nonpermanent Vis-à-Vis overhead markers (which are used to draw on overhead projector transparencies and can be wiped off).

The students would take turns closing one eye and sitting very still while tracing the student sitting on the other side of the partition. Mike thought of a clever way to transfer a student's work to paper. He would wet a blank sheet of white paper with a wide sponge. Next, he would carefully apply the wet paper to the drawn image on the plastic surface, smoothing it down with his hands, being careful not to smear the image on the plastic. Then, he would slowly peel the wet paper from the plastic surface. Voilà! The student's beautiful drawing was successfully transferred to the paper.

Since then I've developed this very easy clear clipboard technique to teach students this fun way of observing/drawing/tracing from the real world around them. If the weather does not permit you to go outside to stand in front of a tree, try sitting at your kitchen table with a plant or a flower in a vase in front of you. Experiment with this by placing the flower very close to your clipboard and then moving it far away. As you draw these images, you'll be reminded of all the drawing laws you have been learning, right there in front of you, in the real world! Watch how overlapping, shading, shadow, and horizon pop from the real world to your two-dimensional plastic surface.

Student examples

Take a look at how these students practiced this tree lesson in their sketchbooks. Notice how their different styles are beginning to emerge, just as yours is!

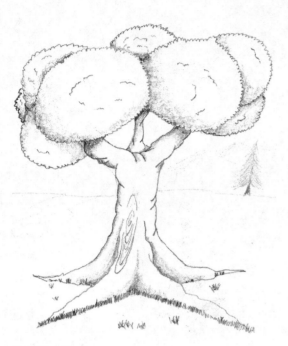

By Michael Lane

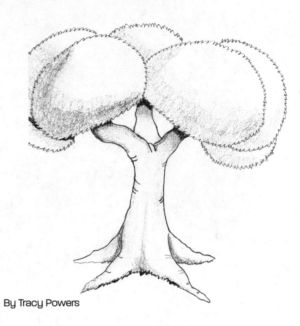

By Tracy Powers

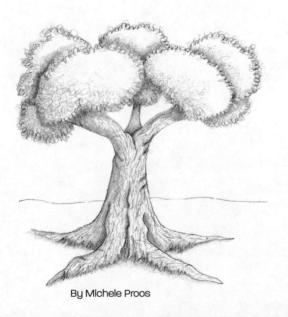

By Michele Proos

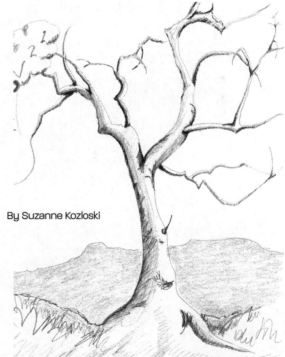

By Suzanne Kozloski

LESSON 22

A ROOM IN ONE-POINT PERSPECTIVE

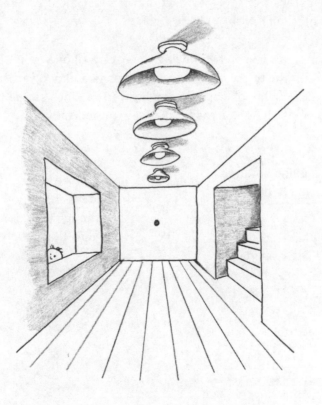

*H*ave you ever wondered what your room would look like if you moved your bed and dresser? Or how your family room would look if you rearranged the couch, chairs, and entertainment center? Has the enormous effort involved in moving everything around just for a "look-see" ever dampened your enthusiasm for a project? This is a wonderful lesson in learning how to draw a room, hall, or foyer in one-point perspective so that you can interior decorate to your heart's content!

In this lesson I will explore one-point perspective, which is a drawing technique involving alignment of all objects to a single focal point in a picture. This technique is also referred to as a vanishing point. Don't confuse this with two-point-perspective drawing, even though the principle is similar. In two-point perspective you use two vanishing points to position your drawings with specific alignment to create depth.

I'm not going to detail how to draw the furniture in this introduction. Honestly, we could spend another entire book of lessons just focusing on drawing furniture, windows, drapes, stairs, doorways, and other interior design details. For this introduction, let's just focus on drawing a really great three-dimensional space that you can fill with your imagination.

1. Let's begin this lesson by drawing the back wall of a room. Draw two horizontal lines lining up with the top of your sketchbook page and two vertical lines lining up with the side of your sketchbook page. Keep your vertical lines straight up and down and your horizontal lines straight across. This is very important.

2. Draw a guide dot in the center of the back wall.

4. Lightly sketch another guide line diagonally through the opposite corners of your room, directly through the center guide dot.

3. Lightly sketch a guide line diagonally through the corners of your room, directly through the center guide dot. I used the edge of a scratch piece of paper as a straight edge, but feel free to use a ruler.

5. Leaving the center guide dot, erase your extra lines.

6. Lightly sketch in the position of the door. Notice how we are using the drawing concept size. The near edge of the door is drawn larger to create the illusion that it is closer to your eye. Draw the floor, walls, and ceiling, always keeping in mind how size affects depth.

← LARGER = SIZE!

7. Using the center guide dot as your reference point, sketch a guide line from the top of the near edge of the door all the way to the center vanishing point. This center guide dot will be the focal point of nearly every line in this drawing.

8. Draw a window on the opposite wall by blocking in the position with two vertical lines. Remember to draw the near edge larger.

LARGER = SIZE →

9. Once again, referring to your center guide dot, draw the top and bottom edges of the window. Pretty cool, eh?

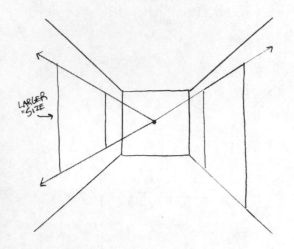

10. Horizontal and vertical lines are used to illustrate thickness in one-point perspective drawings. Draw horizontal thickness lines for the doors, windows, and stairs.

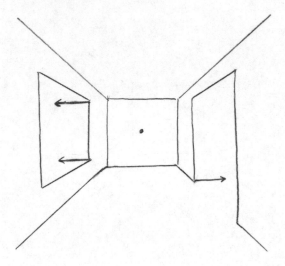

11. Now draw a vertical line to define the thickness of the window. Is the window in a three-foot-thick stone castle wall or a much thinner brick or wooden wall?

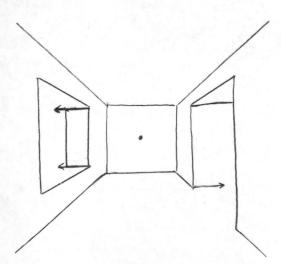

12. This step is a very important part of this lesson. Using the center guide dot as your reference point, lightly sketch in the top and bottom of the window. Voilà! You have created a window in one-point perspective! Now let's work on the stairs.

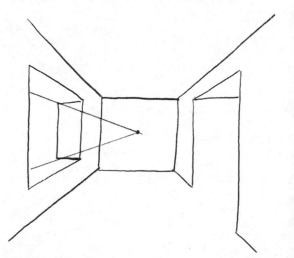

13. Using the back walls as your reference lines, draw horizontal and vertical lines to create the far edge of the stairs. Do you remember in step 1 how I stressed the importance of those first horizontal and vertical lines? Well, this is why. All of your remaining horizontal and vertical lines must be parallel to the first ones, or your drawing will visually collapse.

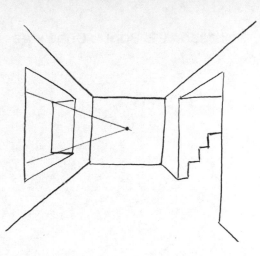

14. Time to use the center guide dot again. Line up each corner of each step with your center guide dot. I'll be referring to this as "line alignment" in future lessons. Draw light sketch lines out from the center guide dot as I've illustrated.

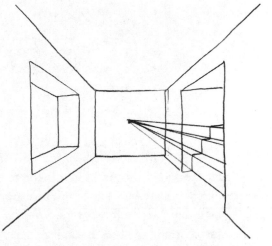

15. Clean up your extra sketch lines. Sharpen all the edges to really bring your drawing into focus. I've shaded the drawing with the light coming from the outside left window and the ceiling lights off. If the ceiling lights were on, where would the shading be? I've added floorboards and a row of ceiling lamps. Redraw this one a few times, experimenting with different doors and windows.

Lesson 22: Bonus Challenge

By Michele Proos

This sketch was drawn from one of my online animated tutorials at www.markkistler.com. I was inspired by one of my favorite M. C. Escher drawings. Take a look at M. C. Escher's one-point-perspective drawings online. You will also see many two-point-perspective drawings, a really cool technique that we will be discussing in a later lesson.

Lesson 22: Bonus Challenge 2

Grab your plastic clipboard and black fine-tip Sharpies from Lesson 21's Bonus Challenge. Tape a sheet of plastic Write-On Film to your clipboard, as you've done before. Settle yourself anywhere in your room. Sit at your desk, on your bed, on the floor, wherever you are most comfortable and in a position that gives you the best view of your room. Using your lightweight portable easel, or a few cardboard boxes, position your clipboard so that when you look through it with one eye closed, the back corner wall is a vertical line, matching closely with the vertical edge of your clipboard.

Trace everything that you see: the edges of the walls, ceiling, floor, windows, and furniture. Make sure not to move the clipboard once you start to trace. Place your

drawing on a scanner, and print a copy. Use your pencils to shade your print, adding multiple tones and values where you see them in the room. Notice the real-world nook and cranny shading, the shadows, and see how placement, overlapping, and size really do impact your visual world. Is this fun or what?

Take a look at how Michele used the clear clipboard method to draw her room. The illustration below on the left is her ink on clear transparency tracing, and the illustration on the right is her example of copying the transparency on regular paper, then adding shading and details to the print. Cool!

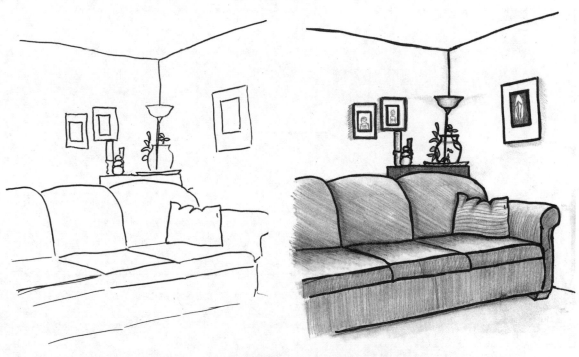

By Michele Proos

Student examples

Here are two different outcomes from two students completing the same lesson. I just love seeing these results!

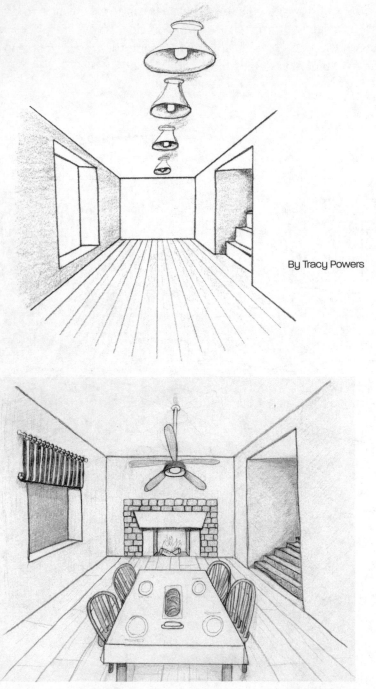

By Tracy Powers

By Marnie Ross

A CITY IN ONE-POINT PERSPECTIVE

*B*y learning to draw a room in one-point perspective in the previous lesson, you practiced the important basic skill of creating a single vanishing point. Let's take this idea a step further and draw a downtown city block in one-point perspective, where all the buildings, sidewalks, and road seem to "vanish" at a single point in the far distance. Take another look at the drawing of the city on the previous page. Looks really fun to draw, right? It is! And it's a lot easier than it looks. In this lesson I will be reinforcing your understanding of several laws of drawing: size, placement, overlapping, shading, and shadow—as well as the principles of attitude, bonus details, and constant practice.

> ### Defining Perspective
> In drawing, perspective is used "to see" or create the illusion of depth on a flat surface. The word "perspective" is rooted in the Latin word *spec*, meaning "to see." Other words rooted with *spec* include "speculate" (to see possibilities), "spectator" (one who sees an event), and "inspector" (one who sees clues).

1. Draw a horizon line with a guide dot placed in the center.

2. Similar to the guide lines you drew to position the ceiling, walls, and floor in the one-point perspective room, draw these guide lines to position the buildings and the road.

3. Draw a vertical line where you want your buildings to start on the left side of your paper. Then draw a vertical line where you want your buildings to end, also on the left side of your paper. Make sure to keep your vertical lines straight so that they match the edge of your sketchbook. Feel free to use a ruler or straightedge to draw the lines. When I draw small one-point perspective illustrations, I often sketch freehand, without a straightedge. Try drawing this lesson both ways, with a ruler, then freehand. Which is more enjoyable for you?

The ruler drawing will appear hard-edged and precise, whereas the freehand won't be as technical looking, but it will have your special hand-drawn stylistic feel. I hesitate to suggest that students experiment with using a straightedge in this lesson because some students tend to become dependent on this tool. Please understand that the straightedge is just another drawing tool in your quiver, just as the blending Stomp is an extremely helpful tool. If need be, however, you *can* draw just fine without it.

4. Now do the same for the right side of your drawing. Draw vertical lines to indicate the position of the buildings.

5. Make sure that the buildings' top and bottom lines match up with your vanishing point.

6. Draw horizontal lines, matching the horizon line (your eye level) from the top and bottom corners of each building on the left side of the drawing. This is the moment when your drawing really snaps off the page!

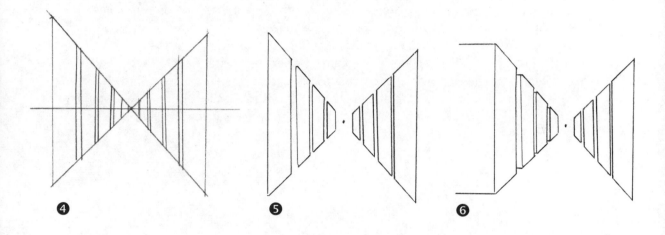

7. Draw the horizontal thickness lines on the buildings on the right side of the drawing.

8. Draw the road and the center divider lines. Shade the building block forms. I've positioned my light source at the vanishing point, so I have shaded all the surfaces facing away from the vanishing point.

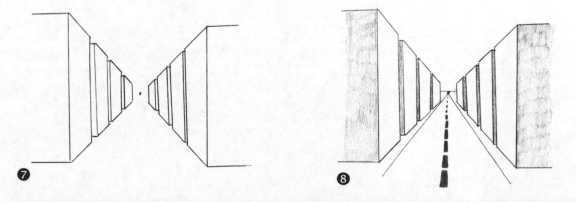

Lesson 23: Bonus Challenge

This lesson was inspired when I was crossing Fifth Avenue in New York City. I looked down the middle of the street and saw the towering buildings, the river of yellow taxis, and even the crowds of people on the sidewalks, all lined up in one-point perspective! I stopped in my tracks and thought, "What a great drawing lesson this is . . . " when a taxi blared his horn and yelled at me to get out of the street!

Another inspiring moment for this lesson was when I was shopping at the grocery store, rolling down the canned vegetable isle and . . . "Whoa! Major one-point perspective lesson!"—all 10,000 cans are all lined up to one vanishing point! It's really very cool. Oh! I just remembered another great location for one-point inspiration—the library! All the books on the shelves are in wonderful one-point perspective rows! You should try this yourself next time you are at the grocery store or the library. It makes the idea one-point perspective crystal clear!

Redraw the lesson below, and add a ton of extra ideas. You can see how I've added doors, windows, and a few neighbors. Have fun with this one. Draw awnings, stoops, and maybe a flower box or two. Details truly are the spice of life!

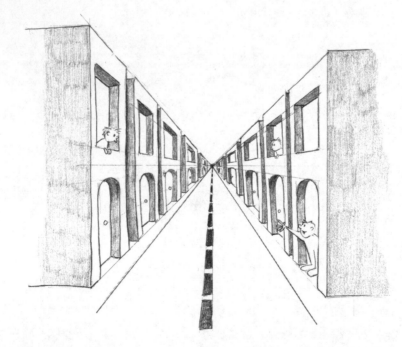

Lesson 23: Bonus Challenge 2

Why stop here? Why not apply this one-point perspective technique out in the real world to really see how it works? Grab your clear clipboard with a piece of clear Write-On Film taped to it, along with your fine-point black Sharpies. Walk down your driveway to the street. Look down the street, either way (it doesn't matter); just pick the direction that is the most visually interesting. Close one eye, and trace what you see by looking through your clear clipboard. To stabilize your arm, lean against a stationary object, such as your mailbox or a parked car. Your vanishing point is going to be a bit off to the right or left of center as you will not be standing in the middle of the street. However, you will be delighted with your black ink tracing. Pretty neat to see how this vanishing point works in reality, yes?

Try this sitting on a bench downtown, in the park, or on a pier. I actually did this in a department store while looking up the escalators. I couldn't resist! The uniformity and repeated pattern were just too visually compelling. A thousand escalator steps all lined up to a single vanishing point. A veritable one-point-perspective drawing lottery win! After the sixth curious stare from a passing shopper, I put my clipboard down, but not before I finished the tracing of the foreshortened escalator.

You can achieve a similar exercise by taking a photo and placing a clear plastic Write-On Film over it. It's not as fun or adventurous (or as annoying to people trying to get around you on the sidewalk), but taking digital pictures of your target view is another way to make this exercise work. For example, when I was inspired by the one-point perspective view while walking along Fifth Avenue in New York City, I should have taken a picture rather than stopping in the middle of the sidewalk to draw amid several hundred hurried New York pedestrians. It took five attempts, crossing an intersection over and over again, to successfully capture the image in my mind.

Student examples

Here are three great student examples from this lesson to inspire you to keep drawing every day!

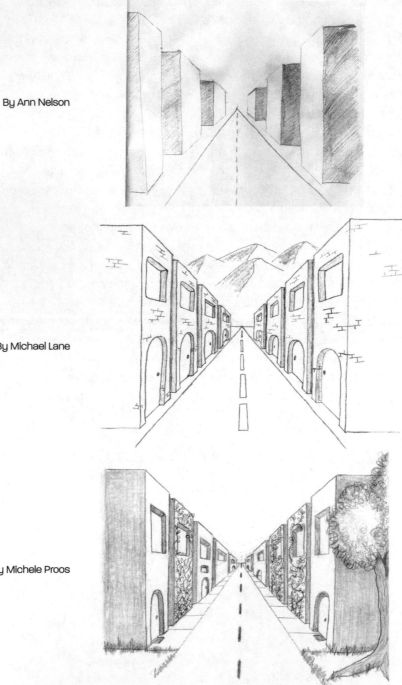

By Ann Nelson

By Michael Lane

By Michele Proos

A TOWER IN TWO-POINT PERSPECTIVE

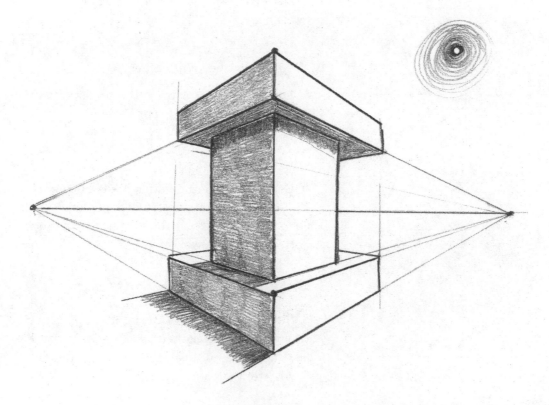

*J*f you enjoyed experimenting with one-point perspective, you are really going to have fun with two-point perspective. Two-point perspective is using two guide dots on a horizon line to draw an object above and below your eye level. I could go on for three pages elaborating on this definition, but as you and I now know, a picture is worth a thousand words, so let's draw.

In this lesson we will really focus on the laws of drawing size and placement. With these two vanishing-point guide dots, you are going to see immediately why size and placement are such powerful concepts.

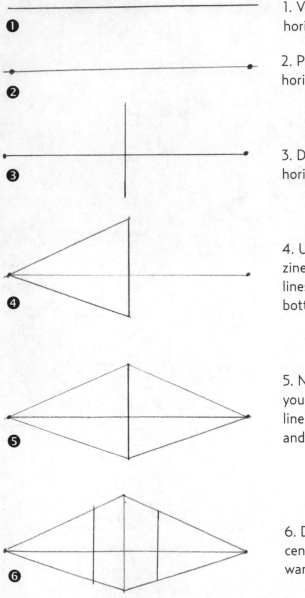

1. Very lightly, sketch a horizon line. Draw this horizon line all the way across your paper.

2. Place two vanishing-point guide dots on the horizon line.

3. Draw a tall vertical line in the center of your horizon line to position your tower.

4. Using your ruler or a straightedge of a maga-zine, book, or scratch piece of paper, draw guide lines from the left vanishing point to the top and bottom of your tower.

5. Now do the same for the right side. Using your ruler or a straightedge, lightly draw guide lines from the right vanishing point to the top and bottom of your tower.

6. Draw two vertical lines on either side of your center vertical line to determine how thick you want the tower to be.

7. Darken and define the edges of your tower and horizon line. Erase your extra guide lines. Draw a guide dot below the center bottom corner of your tower. Add guide lines lining up with your vanishing points. This will begin to shape the pedestal.

8. Using your vanishing points, draw in the back sides of the pedestal. Now, repeat this process to begin to shape in the top capstone of the tower.

9. Draw the sides of the capstone and pedestal with two vertical guide lines.

10. Draw the thickness lines for the pedestal and the capstone lined up with the vanishing points.

11. Determine where your light source will be positioned. Add a cast shadow opposite the light source. This drawing is an excellent visual example of how the Nine Fundamental Laws of Drawing work and why. For example, using your straightedge to extend the bottom right edge of the tower in a southwest direction will position the cast shadow lower on the surface of the page, making it appear closer (placement). Also, by using these vanishing points, you have drawn the near corner of your tower larger (size). Adding shading to all the surfaces opposite the light source will create the illusion that the tower is standing in a three-dimensional space. Notice how I've added a cast shadow under the top capstone and at the base of the center column. Cast shadows are powerful tools to help visually hold the objects' components securely together, like visual glue.

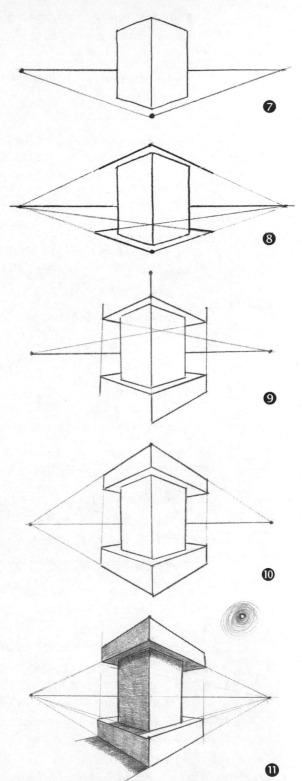

Let's review how we've applied the Nine Fundamental Laws of Drawing to a two-point-perspective drawing:

1. **Foreshortening:** Look at the bottom pedestal of the tower. Notice how the top of this pedestal is a foreshortened square. By distorting this into a foreshortened shape, you create the illusion that one part is closer to your eye.

2. **Placement:** See how the lowest point in the tower is also the nearest point in your drawing. The lowest point of the tower appears to be closer.

3. **Size:** Notice how the largest part of the tower is the center. This is where the guide lines to both side vanishing points come together. The largest part of the tower appears to be closer.

4. **Overlapping:** Look at how the center column of the tower partially blocks the view of the pedestal and the capstone. This overlapping creates the illusion of near and far.

5. **Shading:** Shading the tower opposite the light source creates depth.

6. Shadow: Using the right vanishing point to draw the shadow guide line visually anchors the tower to the ground, rather than have it appear to be floating in space.

7. **Contour:** You could add a water pipe jutting out of the building using one of the vanishing points as a direction guide to draw your contour lines.

8. **Horizon:** Look how the entire drawing is based on the position of the horizon line between the two vanishing points.

9. **Density:** You could draw other smaller buildings behind this tower, lined up with these same two vanishing points. You would draw them lighter and less distinct to create the illusion of atmosphere.

An excellent way to remember all Nine Fundamental Laws of Drawing is to create a wacky cartoon story in your imagination based on the first letters of each of the Nine Laws in proper sequence (F, P, S, O, S, S, C, H, D). Here is what I teach in my classes, but feel free to create your own wild visual images. The more outlandish and exaggerated your story is, the better your recall of it will be. In your imagination picture "fluffy pillows surfing on super small carrots holding dinosaurs."

This is a fun, whimsical whacky visual chain that will enable you to remember these Nine Laws forever! I'm serious. I taught a big burly cowboy named "Rock" (who just happened to have won the world bull-riding competition in New York City!) this memory trick on an airplane in less than four minutes! He then drew a very cool rose in 3-D for his wife. Yes, I do have the most interesting weekly plane rides!

Lesson 24: Bonus Challenge

Now, let's draw a second tower, with multiple levels and varying widths.

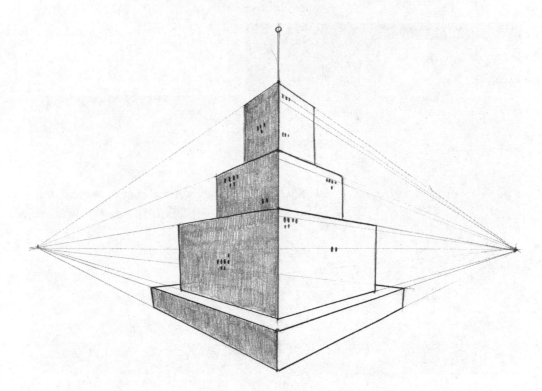

1. Draw a horizon line all the way across your paper. Place your vanishing points near the outside edges of your paper as far apart as possible. If you place your vanishing points too close together, your two-point perspective will look skewed, as if you were looking through a fishbowl. This is actually a great point to explore on your own. Try drawing this tower several times, each time placing the vanishing points closer and closer together. If you do, you will notice increasing distortion. A good example of this is M. C. Escher's *Self-Portrait in Spherical Mirror*, where he drew a portrait of himself looking into a round glass globe (Google it when you get a chance).

2. Draw the center line to position your tower.

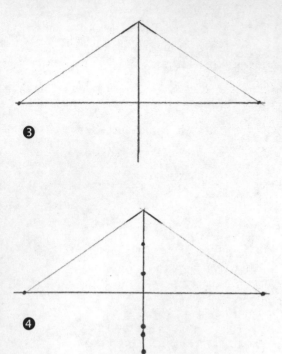

3. Using your straightedge or a side of a piece of paper, lightly sketch in the top of the tower with guide lines from the vanishing points.

4. Draw guide dots down the center vertical line to determine the position of the tower levels.

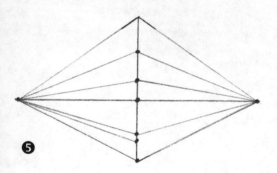

5. Using a ruler or any straightedge, lightly draw the guide lines from each center guide dot to the vanishing points.

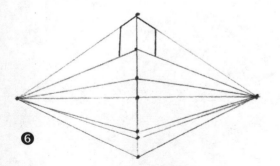

6. Define the top tower with vertical lines. Pay attention to these vertical lines, and match them with your center vertical line. You can also double-check the vertical angle of these lines with the vertical side edges of your drawing paper.

7. Define the next two levels, making sure to keep the sides vertical.

8. Draw a level of the tower both above and below your eye level. Remember that your eye level is the horizon line.

Be very attentive to the vanishing points when you draw the back edge of the bottom foreshortened platform. Notice how this line disappears behind the wall of the tower, not into the corner, but behind the corner. This is the most common mistake that many students make.

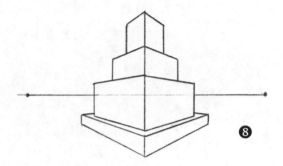

9. Complete this two-point-perspective multilevel tower by adding shading, shadows, and details, such as tiny windows. By drawing small windows, you create the illusion that the tower is enormous. (Likewise, drawing big leaves on a tree makes the tree look smaller; drawing small leaves on a tree makes it appear larger. Draw big eyes on a face to make it look smaller, like a baby; draw small eyes on a face to make it look larger and older.) Playing with proportion is a wonderful trick, which we will dive into more deeply in a later lesson.

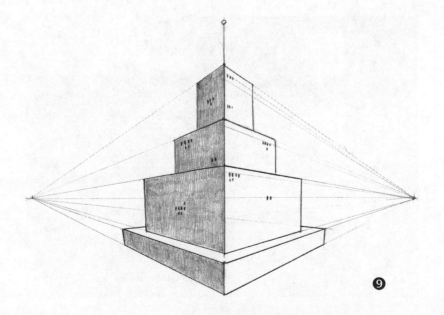

Student example

Take a look at how this student practiced this lesson. Nice job, eh?

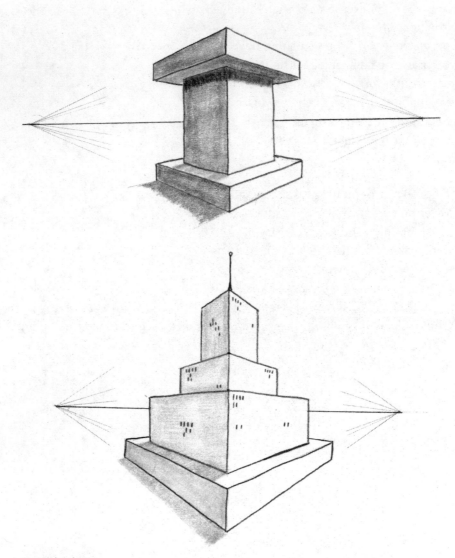

By Michael Lane

A CASTLE IN TWO-POINT PERSPECTIVE

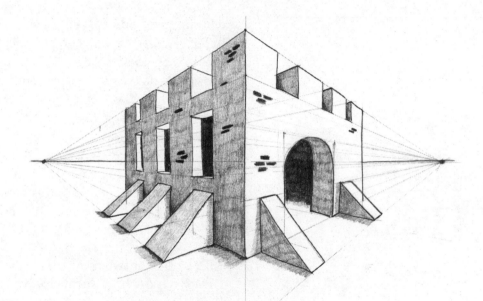

As you enjoyed that very cool two-point-perspective tower in the last lesson, let's explore this two-point (vanishing point) a bit more. Ever since my first visit to Europe thirty years ago, I've been fascinated by castles. It seemed to me that there was a castle or two in every village, hamlet, town, and major city. What really amazed me was the age of these enchanting castles, often several hundred years old. I remember the adjacent pubs had thick wood tables with names carved into them dating back to 1700s, whoa!

In this lesson we will build on your two-point-perspective drawing skills by applying size, placement, shading, shadows, and repetition. We will practice using the vanishing points to create the visual illusion of a medieval castle really existing in three dimensions on your paper.

1. Draw a long horizon line across your paper.

2. Establish your two vanishing points by drawing two guide dots as I have illustrated. The farther apart you can place these guide dots, the better. If you place your guide dot vanishing points too close together, your two-point-perspective drawing will become really distorted, much like looking at an image on the back of a spoon or round bowl. A good example of this would be M. C. Escher's *Self-Portrait in Spherical Mirror*, where he is looking at his own reflection in a reflective sphere.

3. Draw the center line of the castle, half above your eye level, half below your eye level. Notice how the terms "horizon line" and "eye level" can be interchanged.

4. Lightly sketch the guide lines for the top and bottom edges of the castle.

5. Place two guide dots above your eye level, and two below your eye level on the center line of the castle. This will establish the guide lines for the turrets, windows, and buttress ramps.

6. Lightly draw all the guide lines using a straightedge. Over the years I've experimented with many helpful devices for drawing these vanishing-point guide lines. One of my favorites is securing a rubber band between the two vanishing points with a piece of cardboard behind the drawing and thumbtacks on the vanishing points. I will discuss this technique in detail in this chapter's Bonus Challenge.

7. Draw the turrets, making sure to pay attention to the vertical lines.

8. Carefully line up your straightedge from the top near corner of each turret with the opposite vanishing point. If the turret is on the right side of the castle, line up the thickness with the left vanishing point. If the turret is on the left side of the castle, line up the thickness with the right vanishing point—just the opposite of the thickness rule. This is because the thickness rule applies to doors, windows, holes—to spaces cut out of a drawing. The turrets are actually blocks pushing out of the object. If you had drawn a top level above the turrets closing them into windows, we would be back to the thickness rule. Interesting?

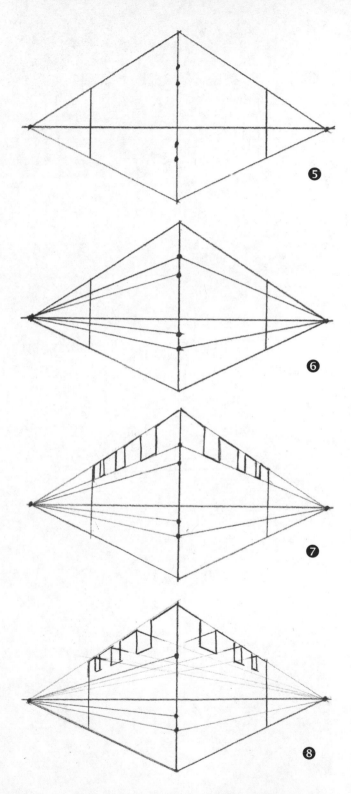

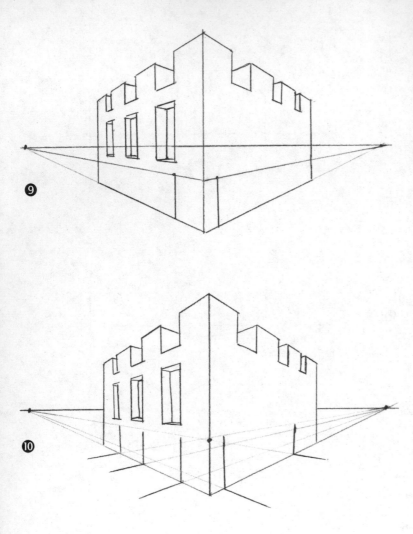

9. Draw the windows on the left side of the castle by lining up the top and bottom of the windows with the vanishing point on the left side. Pay attention to the vertical lines. Sagging windows would be very distracting. Easy problem to avoid: Just keep darting your eyes from the vertical edge of your paper to the vertical center line to the vertical line you are drawing. In the time it takes me to draw one window's vertical edge, I've probably darted my eyes to the sides and center three or four times.

10. Now, we go back to our tried, tested, and true thickness rule: If the window is on the right side, the thickness is on the right side; if the window is on the left side, the thickness is on the left side. Use your straightedge to line up the far top corner of each window, with the vanishing point on the right side. Draw the thickness as wide or as thin as you like.

11. Draw the rows of buttress ramps with vertical lines. Draw the bottom of the ramp lined up with the opposite vanishing point.

12. Draw the top slant of the buttress ramps. Keep this angle in mind, as all the ramps that follow will match this angle exactly.

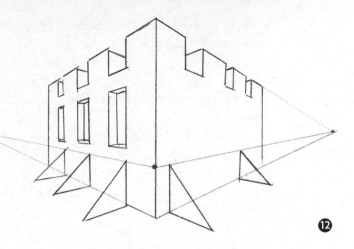

13. Lightly sketch in vanishing-point guide lines from the top and bottom corners of the buttress ramps on the right and left side of the castle.

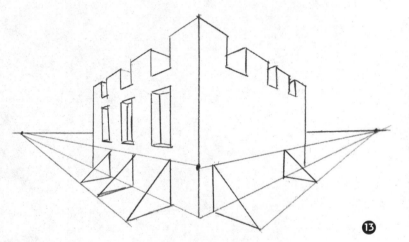

14. Matching the near angle of the ramp, draw the thickness of the first ramps. Then leaving a gap, draw the next ramp by matching the same angle. Be sure to draw this next ramp thinner and smaller than the near ramp.

Here is a perfect visual example of the drawing law of size: The near ramp is closer and thus drawn larger. Each subsequent ramp is drawn smaller to give the illusion of depth. This is also a perfect example of the drawing law of placement: The near ramp is drawn lower, creating the illusion that it is closer. The next ramp is placed higher to make it look farther away.

Add the front entrance on the right side of the castle. Line up the bottom far corner of the door with the vanishing point on the left side.

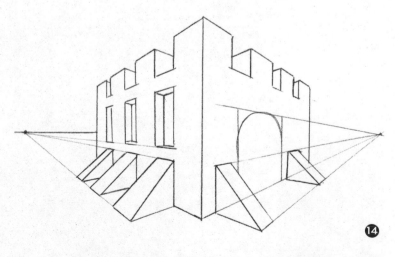

15. Determine your light position, and shade the castle accordingly. Notice how I have shaded under the doorway arch. I've kept the window thicknesses shade-free to give the illusion that light is coming from within. Also notice how the nonshaded window ledges really pop out next to the black interior on one side and the gray-tone shading on the other side. This is called contrast. Contrast between values defines an object.

To complete the drawing, add details, such as bricks. Be sure to use your vanishing-point guide dots to appropriately line up the bricks' angle, as I did in the drawing below. In most cases, when you're adding textured detail, in this case the bricks, a little goes a long way, meaning that a scattered few groups of texture will give the illusion of full texture.

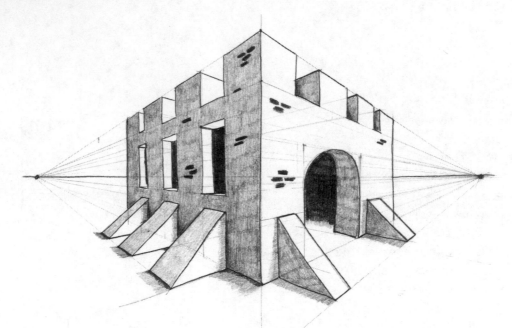

Lesson 25: Bonus Challenge

1. Find a piece of cardboard about twelve inches by eighteen inches. You don't need to be exact—any size will do. In fact, you will most likely be making several of these contraptions of varying sizes.

CARDBOARD ❶

2. Secure a piece of paper to the center of the cardboard, leaving at least three inches of space to the left and right of your drawing paper.

TAPE PAPER ❷

3. Draw a long horizon line through the center of your drawing paper, extending it all the way off both sides of the cardboard backboard.

❸

4. Draw vanishing points at each end of the horizon line.

❹

5. Put a pushpin into each vanishing point.

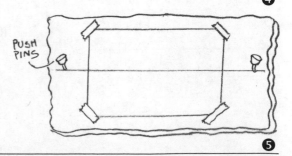

PUSH PINS

❺

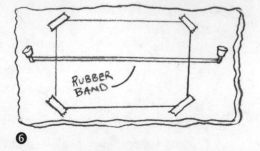

6. Secure a thin rubber band between each pushpin.

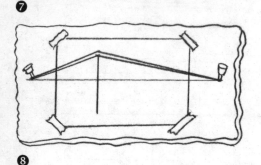

7. Whoala! You now have a totally flexible vanishing-point guide line. You can stretch this vanishing-point guide line to determine the correct two-point-perspective vanishing angle of any object in your drawing. Go ahead, experiment! Draw a vertical line anywhere on your paper.

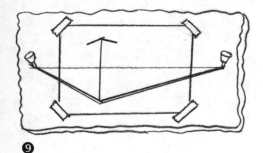

8. Now, use your rubber band to line up the top of the building.

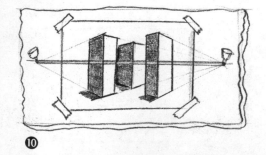

9. Now, use the rubber band to draw the bottom of the building.

10. To complete the drawing, add more vertical lines, shading, and detail. You have mastered yet another brilliant drawing using 3-D techniques!

Student examples

Take a look at how these students practiced this lesson in their sketchbooks.

By Michael Lane

By Ann Nelson

A CITY IN TWO-POINT PERSPECTIVE

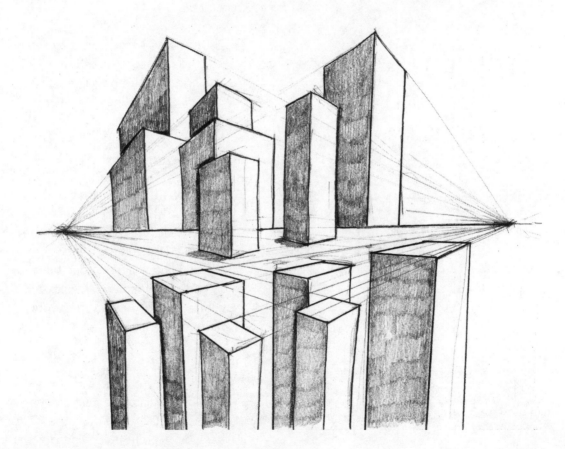

*T*ake a look at the illustration on the previous page. Fantastic fun! This is a wonderful exercise for practicing a more advanced two-point-perspective challenge. I established practice as one of the ABCs of Successful Drawing because it is nearly impossible to learn and master a new skill without engaging in intense repetitive practice. Music, language, reading, sports, and, most definitely, drawing demand practice for a person to really understand and enjoy them.

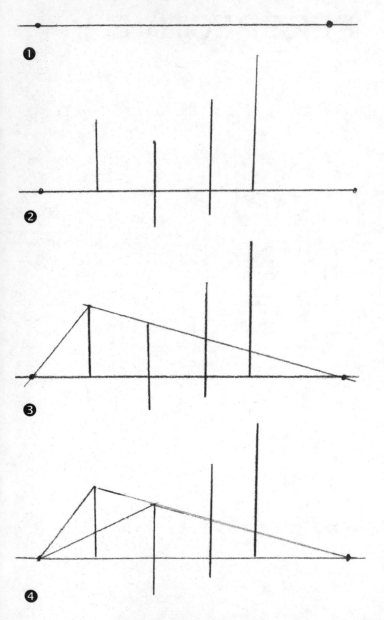

1. Lightly draw your long horizon line, stretching across your entire paper. Draw your two vanishing points.

2. Draw four vertical lines to establish the near corners of four city buildings. Notice how I've drawn only two of the lines above and below the horizon line.

3. Begin with the building on the left. Lightly draw the vanishing-point guide line for the top of the building. Notice how the bottom of the building will be hidden beyond the horizon line; it will be beyond your eye level, hidden from your point of view.

4. Move over to the next building to the right. Lightly draw the vanishing-point guide lines for the top and bottom of this building.

5. Move over to the next building, and keep repeating this process, using vertical lines to complete these first buildings.

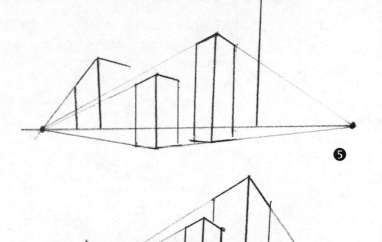

5

6. Using overlapping, draw this far right building tucking behind the closer building.

6

7. Draw some additional vertical lines from the tops of the other buildings to create the illusion of depth and to create the look and feel of a crowded city skyline.

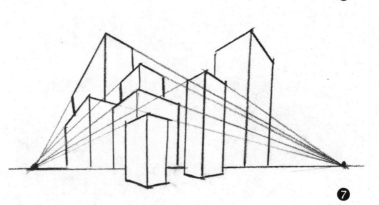

7

8. Clean up your extra lines.

8

9. Lightly draw the vanishing-point guide lines to create the top of the building. Decide where you want your "below-eye-level" buildings to be by drawing a vertical line. This will establish the near corner of the building.

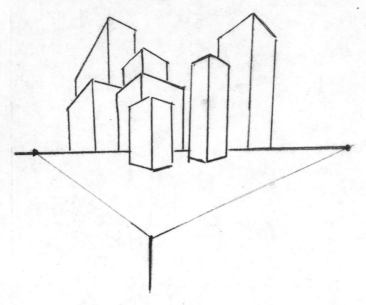

10. Define the thickness of the tower with two vertical lines.

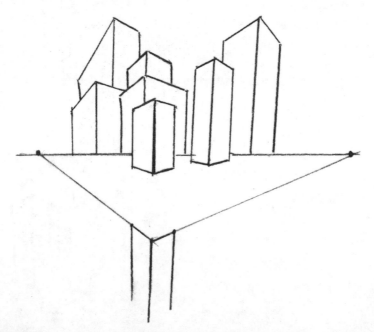

11. Use your straightedge to draw a light vanishing-point guide line from the back right corner of the roof.

Do the same thing on the other corner, and voilà, you have a slightly opened foreshortened square. Now, you CAN actually see why we practiced so many of these foreshortened squares in the previous lessons. Foreshortened squares are an ideal example of how two-point perspective works. You CAN draw in 3-D without understanding two-point perspective, just as you can drive a car without knowing how the engine works, or use a computer without knowing how it works. However, understanding two-point perspective opens up a whole new view of creative possibilities for your future drawings.

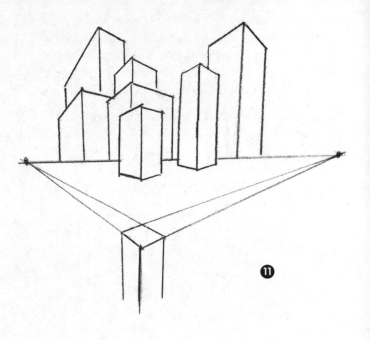

12. Begin another skyscraper with a vertical center line.

Using your straightedge, lightly draw the vanishing-point guide lines to create the roof. For this exercise, let's just draw our buildings so tall that they extend below our field of vision. Just draw all your vertical lines for these below-eye-level buildings running right off the bottom of your paper.

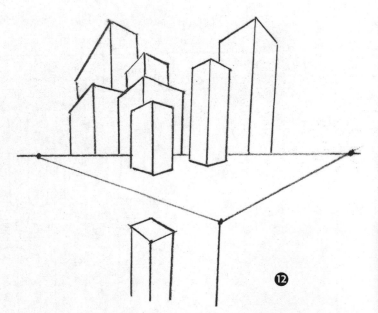

13. Draw the vertical lines to define the width of the building, and lightly draw the vanishing-point guide lines to create the roof.

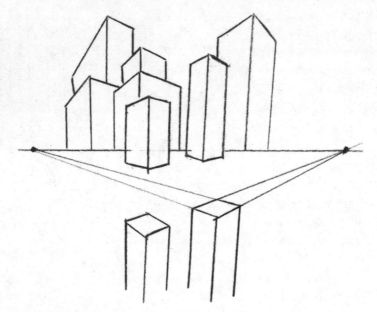

14. Draw all of the buildings, repeating this vanishing-point guide line technique over and over again.

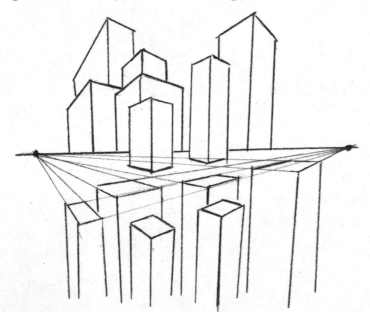

15. Determine where your light source is positioned, and shade all surfaces opposite that light position. Notice how I've punched out the edges of the overlapping buildings by really digging in with my pencil to get that very dark nook and cranny shadow. This dark edging, or defining of objects that are in front of other objects, is a very important tool that nearly every illustrator uses. Now that you know what to look for, I challenge you to find a comic, a magazine illustration, or a museum painting that does not use this technique to define and separate objects.

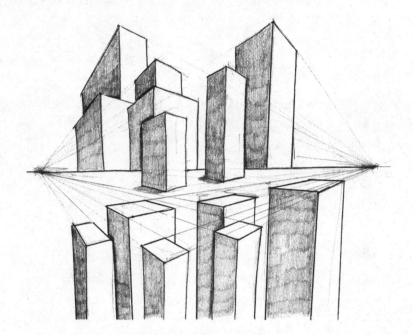

Lesson 26: Bonus Challenge

Here's a fun and interesting bonus-level challenge for you: Go online and search for images of Neuschwanstein Castle, a famous castle in Germany. This castle is believed to be the inspiration behind Cinderella's castle at the Walt Disney World theme parks and on the Disney movie logo you may have seen in the theater or on a DVD. Browse through several images of Neuschwanstein online until you find one you really like. Be sure to choose one that has your eye level positioned toward the bottom of the castle, with all the spires reaching for the sky above your eye level.

Enlarge this image to fill your computer screen, and print it. Tape this photo image to a piece of cardboard, once again making sure the cardboard is larger than the image by three inches on each side. Now tape a clear piece of plastic Write-On Film over the photo.

Use a ruler and a black fine-point Sharpie pen to find and trace the eye-level horizon line in the photo. Now, draw the guide lines from the highest point and the lowest point of the castle to position the vanishing points. Continue drawing as many of these guide lines from angles that you can find in the photo, dashing these lines off the castle to the vanishing points.

Notice how all of the windows on both sides of the main building all line up with the angles of the dark roof, the jutting roof spires, and the jutting roof windows. Look at how even the smaller-side castle and the tall-side guard tower all line up with the vanishing points as well.

Student examples

Take a look at how some students practiced this lesson in their sketchbooks. This is a great lesson for you to draw three or four times in your sketchbook, adding lots of extra detail, such as people, windows, and doors.

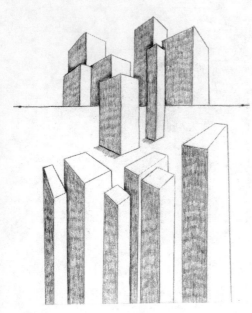

By Michele Proos

By Ann Nelson

LETTERING IN TWO-POINT PERSPECTIVE

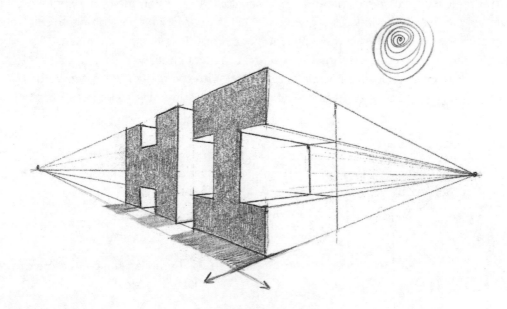

*D*o you remember how cool the opening sequence of the first Superman movie looked? (I know I'm dating myself here; the film was made in 1978.) Go ahead and Google an image of the poster for *Superman, the Movie.*
That very cool, superslick title lettering that you see is an example of two-point perspective. When I saw this movie in high school, I became obsessed with lettering in two-point perspective. Just as a side note here, notice how the Superman image is created in one-point perspective? Side note to the side note: Do you remember the opening sequence for *Star Wars*, where the battleship flies into view overhead and seems to go on forever? That is a *great* one-point-perspective scene, as is the opening story text rolling onto the screen. Side note three: You can learn a lot about 3-D graphic illustration by studying movie posters!

I've had many of my adult students request that I include 3-D lettering lessons in this book. Because I have limited space in these thirty days to cover more than one lettering lesson, I also recommend you take a look at another one of my books, *Drawing in 3-D with Mark Kistler*, which includes instructions on multiple 3-D lettering styles for every letter in the alphabet, A–Z. For this lesson, I've chosen two-point-perspective lettering because it's the most challenging, the most interesting, and the most visually rewarding. Let's start with the short two-letter word "Hi" in two-point perspective lettering. Then you can experiment with longer words later.

1. Lightly draw your horizon line across your entire sheet of paper. Place your vanishing points at the edges.

2. Establish the center line of the lettering block.

3. Lightly sketch in the vanishing-point guide lines for the top and bottom of the lettering block.

4. Define the block faces of the letters. Be sure the near letter block is larger. This is a great example of size. The letter you want to appear closer will automatically be drawn larger as you follow your vanishing-point guide lines. This will become even more important when you draw words with three or more letters in the future.

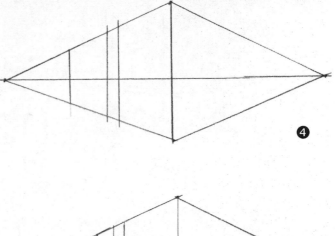

5. Shape the face of the letter *H* by following your guide lines closely. Remember how important the vertical lines are. Dart your eyes to the vertical edge of your paper, and the vertical center line to ensure that your *H* is being shaped correctly.

6. Continue by shaping the letter *I*. You can clearly see now what a predominate role the drawing law of size plays in creating this 3-D visual illusion.

7. Lightly sketch in the thickness vanishing-point guide lines on the right side.

8. Establish the corner thickness of the letter *I* with two guide dots. From those guide dots, draw your vertical thickness and your vanishing-point thickness.

9. Complete the thickness of the letter *I* with the vertical line for the stem. Now, carefully line up all the letter *H* corners with the right-side vanishing point.

10. Position your light source, and shade all the surfaces opposite. Take a few moments to erase any extra guide lines.

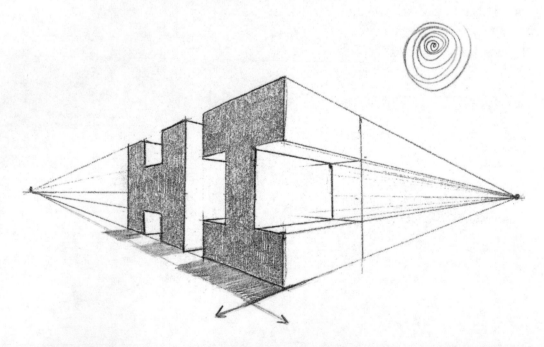

Lesson 27: Bonus Challenge

Instead of providing step-by-step directions, I'm going to provide you with this simple fact: You have practiced (several times) every principle that you need to know to draw the image below on your own. Don't let the final advanced image drain your confidence. Remember it's just one line at a time. Keep it simple. Create your vanishing points. Draw your block, define your letters, and add thickness. Have fun and enjoy. It may take you an hour or more to complete the drawing, so settle in for the ultimate visual game. Look at how Ann Nelson has drawn the letters "Time to Draw" in two-point perspective below. Then look at how Ann Nelson wrote her son's name and how she wrote "United States of America." Think of your own clever word group, and draw it with two-point-perspective lettering.

By Ann Nelson

Student examples

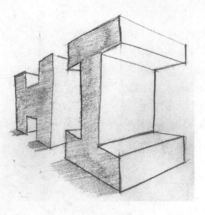

By Ann Nelson

By Ann Nelson

By Ann Nelson

THE HUMAN FACE

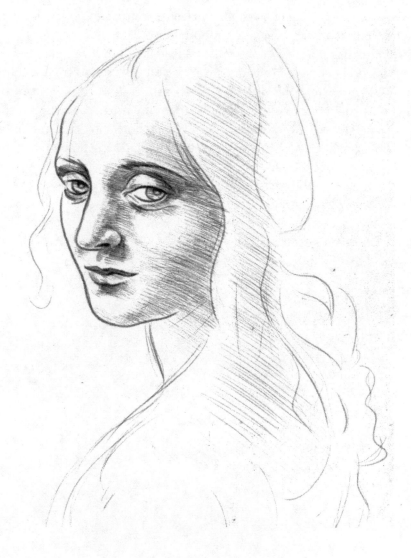

*I*n my opinion, Leonardo da Vinci, Michelangelo, and Rembrandt are the most skilled 3-D illustrators in history. Their sublime talent still inspires awe after five centuries. However, before they were master artists, they were student apprentices. They learned how to draw from their teachers. They learned how to draw by studying, copying, and tracing their teachers' work for years and years.

As I have explained in earlier lessons, the importance of learning how to draw by copying and tracing cannot be overemphasized. After more than thirty years of preaching this philosophy, I still get considerable flack from many art educators who believe that students need to learn how to draw by observation and trial and error. I respect their more conventional approach because it does work with students who have enormous patience and fortitude in their desire to learn how to draw. However, most of the students I've worked with would have quit my classes in frustration had I not given them permission to put aside the false assumption that tracing and copying are cheating.

Whether it is using a clear clipboard to capture an outdoor scene, or using your thumb to measure an object in the distance, tracing will empower your confidence. My point is this: Why reinvent the wheel? Why ask students to sit in front of a model and insist they draw the model without teaching them the most basic tools—shading, shadow, size, placement, overlapping, contour, foreshortening, and the other important drawing laws? Why not have students learn how to draw the human face, figure, and form by tracing the greatest illustrators in history?

For this lesson, I've traced a study of Leonardo da Vinci's *Angel of the Madonna of the Rocks*. I want you to trace this image with a pencil on twenty-five-pound translucent tracing paper. Trace this image ten, twelve, or twenty times on a single sheet of tracing paper; don't worry about the shading yet.

1. Trace the beautiful face, forehead, cheek, and chin with an S-curving line.

2. Trace the nose and the foreshortened nostril. Notice how the tip of the nose is bulbed, as is the bump over the nostril. Draw the nose ridge flowing into the eyebrow above the far eye. Notice da Vinci's use of the drawing law of overlapping.

❸

❹

3. Take your time tracing the soulful eyes using the drawing law of size. Pay close attention to how da Vinci solved the challenge of creating the illusion of depth by drawing the near eye larger, by overlapping the eyelid over the pupil.

4. As da Vinci did, frame her face and forehead with a few wispy simple S-curving pencil strokes of hair.

5. Draw her lips. Notice how the upper lip dips down and how the center ridges under the nose line up with this dip. Look at how the lower lip is made up of two round shaded spheres.

❺

6. After tracing this image about ten times (for about twenty minutes or so), begin a fresh sheet of tracing paper and trace her lovely face again. This time begin shading by removing your tracing paper from Leonardo's drawing and placing it on a white sheet of paper. Now, study how da Vinci shaded her face. Where did he position the light source? Where are the darkest three areas? Where are the lightest three areas? Very lightly shade the three lightest light-reflecting areas. It's always a good idea to move from light to dark. You can always add shade to make an area darker; it's much trickier to make an area lighter.

7. Shading from very light to very dark, study and copy how Leonardo defined the curve of the forehead, eyes, and cheek with blended shading, which we first covered in Lesson 1 with the simple sphere.

Enjoy studying and copying how da Vinci shaded the eyes, eyelids, pupils, and tear ducts—such elegant shading this Master Artist had! Can you imagine Leonardo shading the same tear duct you are? Can you imagine his creative thinking process when he overlapped the lid over the pupil? (Do you feel like you are artistically channeling da Vinci right now? Can you e-mail me the true secret of the *Da Vinci Code*?)

8. Keeping the tip of the nose nearly white to reflect the light, shade the nose with blended pencil strokes. Pay attention to how da Vinci shaped the nostril with only blended shading without any specific hard defining line. Delicately, gently, shade the lips, lightly shaping the two round spheres in the lower lip. Define the center line that separates the upper and the lower lips with two S curves. There you have it. Learning the nuances of drawing the human face from Leonardo da Vinci himself! I urge you to draw several more of these tracings with complete shading. Da Vinci filled sketchbooks practicing, copying, and studying a single face, a hand, an ear, even toes. Google the sketchbooks of Michelangelo, da Vinci, and Rembrandt to get inspired to practice.

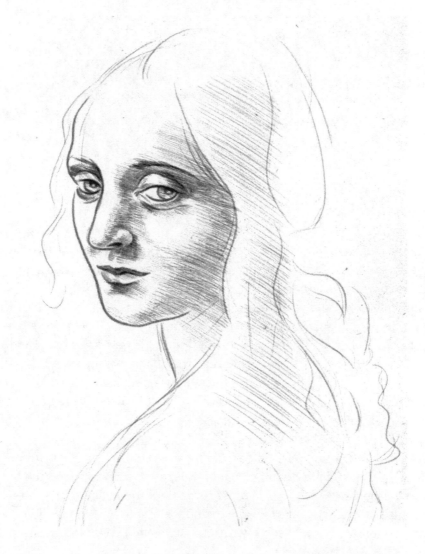

Tracing by Ward Makielski

Lesson 28: Bonus Challenge

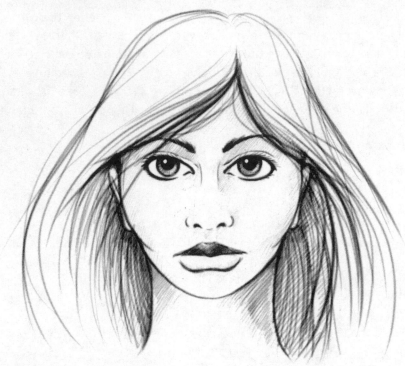

By Ward Makielski

Tracing faces and figure drawings from the great Master Artists is a confidence-building exercise that I hope will inspire you to successfully study, copy, and trace many dozen more faces and figures by da Vinci and others.

This tracing exercise is really fun with photographs as well. Try it out: Pick your favorite photo of your special someone, enlarge it on a copy machine (set the machine to black-and-white grayscale mode if possible; grayscale black and white photos are great to copy/study/trace because the shading really reveals itself).

This is only one brief simple lesson to creatively nudge you to explore more books and illustrations on the human face. Here are two must-have books on the subject: Lee Hammond, *How to Draw Lifelike Portraits from Photographs*, and George Bridgeman, *Drawing Faces*.

Keeping in mind what you studied from da Vinci's drawing, let's learn how to draw a face looking straight at you. For centuries, artists have divided the human figure into mathematical sections in order to transfer the image from the real world to their paper. Let's practice drawing a human face together. I wonder if you will be able to tell the difference between my cartoon style and Leonardo's masterpiece?!

1. Begin the human face by drawing the head as an oval egg with the slightly larger end at the top.

2. Draw a vertical line down the center and a horizontal line near the middle. This will be your guide line to position the eyes.

3. Draw another horizontal line halfway down between the eyes guide line and the bottom of the chin. This will be your nose guide line.

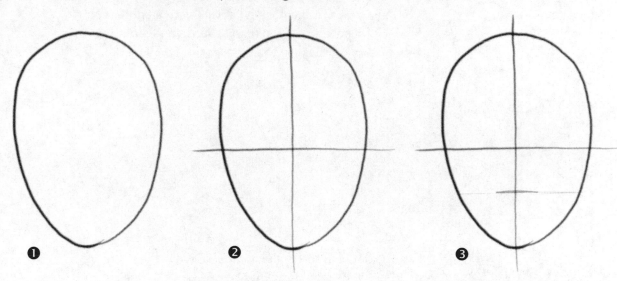

4. Once again, draw another guide line halfway down between the nose and the bottom of chin. This will be your lip guide line.

5. Separate the eye guide line into five spaces. Start in the middle with two lines and work your way out.

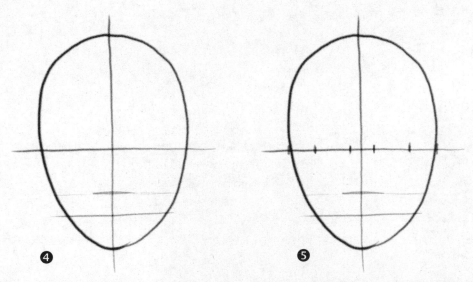

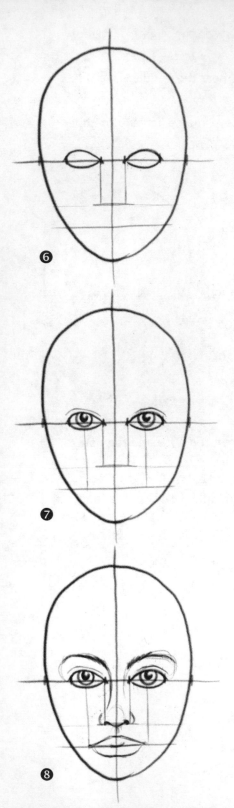

6. Shape in the eyes in a lemon shape with the tear ducts facing in. Shape in the nose from the edge of the eye down to the nose guide line with a light rectangle. Human eyes come in many shapes and sizes. We will be exploring these in the next lesson.

7. Detail in the eyelid and pupil. From the center of the pupil, draw vertical lines to position the lips.

8. Draw the lips, remembering the contour curving shading from your study of da Vinci. Shape the nose and the eyebrows.

9. Did you know the average head weighs sixteen pounds? That's as heavy as a bowling ball. Remember this when you draw in the neck; it has to hold a lot of weight. It's not a Popsicle stick; it's a thick cylinder. The neck starts at the nose guide line, tapers in for the throat, and then tapers out as it leads into the shoulders. Sketch in the hairline halfway between the eyes and the top of the scalp. A common mistake is to draw the hairline too high, so use your guide line. Now, draw the ears using the eye and the nose guide lines. Begin the hair using flowing S curves, keeping in mind the overall shape of the hair.

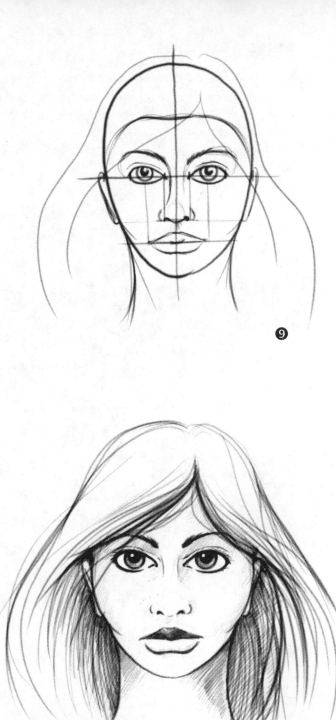

❾

10. Shape the forehead, temples, jawbone, and neck. Draw hair like da Vinci did, with a few defining wisps. Enjoy shading this face with blended shading. Remember to start at the lightest areas first (think of where your own face gets sunburned first): the center of the forehead, tip of the nose, and tops of the cheeks and chin. Focus on keeping these areas reflective and almost white. Add gradually darker shading away from the light source, which for this drawing is above and in front of the face.

Excellent job! You've studied the genius pencil lines of Leonardo da Vinci, and you've learned the mathematical grid structure of the human face.

By Ward Makielski ❿

Student examples

Look at Michele's drawing of the human face lesson below. She did a wonderful job using her own style to interpret the lesson. She has a much more realistic style as compared to my more animation/comic book style. Great drawing, Michele!

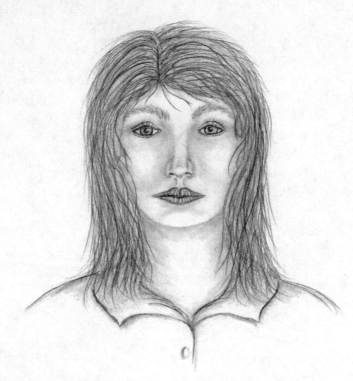

By Michele Proos

Thanks to fellow art educators **Allison Hamacher** and **Ward Makielski** for their considerable help with these lessons.

THE HUMAN EYE
OF INSPIRATION

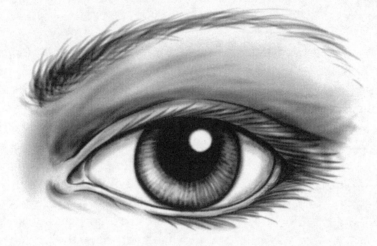

*T*he eye. Without a doubt, it's my favorite thing to draw on humans, creatures, animals, aliens, robots, and, yes, even marshmallows, as I've done on my national public television series. The human eye is most definitely the window into a person's soul. But how to capture it?

To draw the eye in 3-D, I first want you to grab a small mirror. I want you to prop this mirror up next to you while you are drawing at the table. I want you to be able to look closely at your own eye as we draw this lesson. This is a technique I picked up from my visit with some of my alumni students at Dream Works PDI a number of years ago. The animators were working on *Shrek*, and at their drawing animation stations they had several computers, monitors, multiple drawing surfaces, and, interestingly, two mirrors on either side of their drawing tables. As the animators worked on drawing different parts of Shrek, I could see them scowling at their mirrors while drawing Shrek's scowling face. I saw them holding their hands up in different positions while drawing Shrek's hands. It was so exciting to watch these world-class artists bring Shrek to life. Now, let's add life to your own sketchbook—let's draw the eye.

1. While sitting at your table, look into your mirror. Now, look a few moments longer. . . . What a gorgeous miracle you are. Just look at that image! Those eyes! Those lips, nose, ears, hair, what a perfect model to draw from. You traced da Vinci in Lesson 28; now you will drawing from the most perfect eye model on the planet— yourself! Very lightly shape the eye. For this lesson, we will draw an eye that resembles the shape of a lemon, with the bulb of the lemon facing the nose, shaping the tear duct. As you draw more eyes (and you will no doubt draw hundreds more, they are so cool to draw), you will notice there are as many variations for eye shapes as there are people on the planet. For this lesson we will use a simple lemon shape.

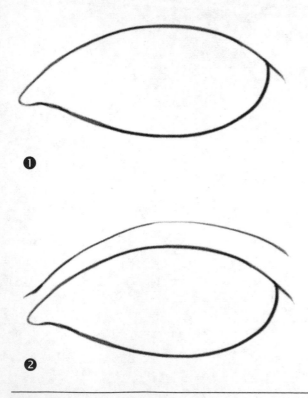

2. Look in your mirror, and take a close look at your left upper eyelid. Notice how the creases follow the contour shape of the eye. Draw the upper eyelid starting at the tear duct.

3. Draw the perfectly round circle of the iris tucked under the upper eyelid just a bit. We are applying the drawing law of overlapping. Remember that the iris is a perfect round circle, not an oval. Look into your mirror. Look closely at the thickness edge running along the top of the lower eyelid. Interesting, tiny details like this one are what you want to look for and draw. These are the details that will really give your eye drawing the "wow" factor. Without them, your drawing will not look realistic.

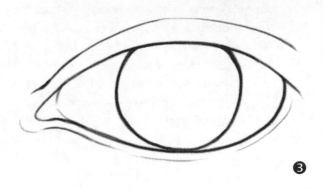

❸

4. Look into your mirror. Look closely at the pupil in the center of your iris. Notice the perfect roundness of the circle. Notice the tiny spots of reflection inside the black circle. Draw the perfect round circle pupil in the middle of your iris. Lightly block out a small circle shape to reserve for the light-reflection effect.

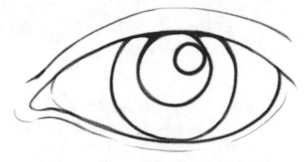

❹

5. Look into your mirror. Look closely at your pupil again. Look at the deep black of the pupil and the brightness of the reflection. Draw this deep black pupil with the light reflection.

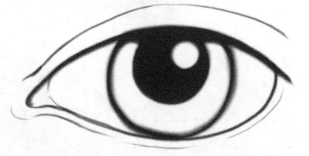

❺

6. Look into your mirror. Look closely at the iris area around your pupil. Look again. Now, look again. Just an awesome play of light, color, moisture, shape, such detail! When you are drawing the iris, use pencil strokes radiating out from the dark pupil, and use a variety of line lengths, some short, some long. When you start experimenting with colored pencils, this is the lesson I would recommend you start with. (Using colored pencils to draw the iris is . . . how would I describe it? A transcendental experience!)

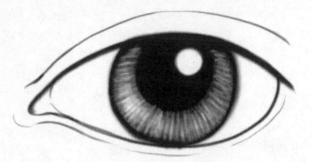

7. Draw your gorgeous eyebrow. Draw individual hair starting at the bridge of the nose and moving across the brow. Draw with flowing single lines, angling the hairs more horizontally as you move away from the nose. Begin shading the eye along the inside of the eyelids.

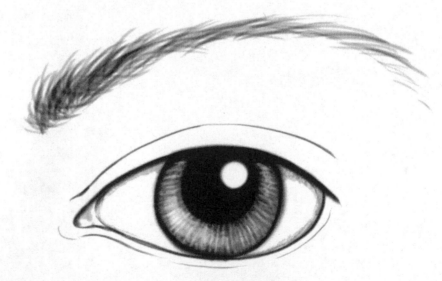

8. Look into your mirror. Look closely at your eyelashes. Notice how your eyelashes are clustered in small groups of two or three, not just single hairs. Notice how the eyelash groups start on the very near thickness edge of the upper lids. Notice how your eyelashes curve away from your lid, following the contour of your eye. Draw a few groups of three eyelashes. Pay attention to your placement. Be sure to draw them at the very near edge of the lid. Pay attention to the direction of the curve of the lashes. Be careful not to draw too many eyelashes, and avoid drawing them too vertically (or else you risk creating what I call the "spider effect").

The next step is shading. This is the lesson step that really pops your eyeball right off the page! There are five specific areas to shade. The first of the five shading areas is directly under the top eyelid, the full length of the eyeball. The second spot is along the bottom lid, above the thickness line, directly on the eyeball. Keep this very light shading at first; you can build up more dark contrast later. (If you start too dark, it will look like some very heavy Goth black eye makeup, unless of course this is the look that you are going for.) The third area is the little crease at the top of your eyelid, the line that separates your eyelid from your eye socket. The fourth shading area is the bottom of the eye socket, darker in the center corner near the nose and tear duct. This shadow is blended and falls into the cheek.

As Leonardo da Vinci used blended shading to define Mona Lisa's eyes without any hard edge dark lines, you too can use blended shading to soften and define your 3-D eye. Be sure to darken and blend the fifth area of shading in all the tiny nook and crannies in the corner of the eye socket and eyelid.

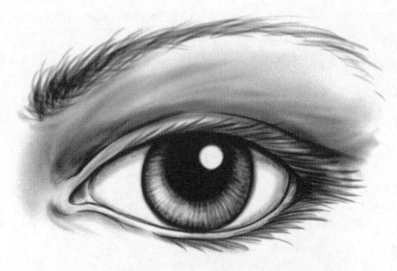

By Ward Makielski

Lesson 29: Bonus Challenge

I love drawing eyes. The more you draw, the more you will enjoy them. Eyes are the single most important element in drawing the human, animal, or creature face. Draw several more eyes in your sketchbook, a few more from looking in the mirror, and a few from searching "How to draw an eye" on YouTube. There are some incredible amateur video tutorials you will thoroughly enjoy.

Student examples

Take a peek at how these students practiced this eye lesson.

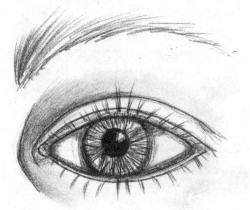

By Allison Hamacher

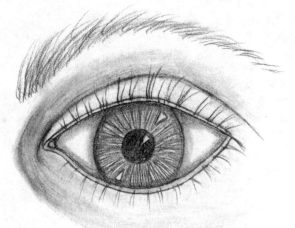

By Michele Proos

YOUR HAND OF CREATIVITY!

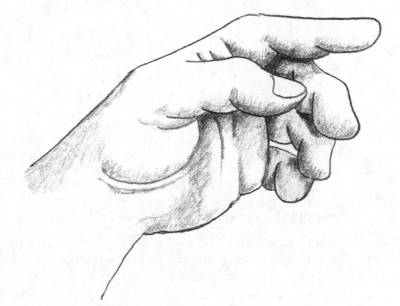

*T*he human hand, our most expressive appendage! In this lesson we will pull together all of the Nine Fundamental Laws of Drawing that we have learned so far and apply them to this drawing. Let's review each of the laws and how they apply to this lesson.

Take a look at the illustration of the hand below and notice the following:

1. **Foreshortening:** The entire hand is tilted away from your point of view. As the hand tilts away, it becomes more distorted from your perspective.

2. **Placement:** The thumb is drawn lower on the surface of the paper than the index finger; this creates the visual illusion that the thumb is closer. The index finger is drawn higher on the surface of the paper so that it appears farther away from your perspective.

3. **Size:** The thumb is drawn thicker and larger in relative size as compared to the other fingers, creating the illusion that it is closer.

4. **Overlapping:** Each finger overlaps the other to create depth in the drawing.

5. **Shading:** All surfaces of the hand facing away from the light position are shaded with blended value from dark to light. Blended shading creates the visual illusion of depth.

6. **Shadow:** The dark shadows between each finger separate and define the object.

7. **Contour:** The wrinkle lines on the fingers and the palm wrap around the full round shape of the hand. These contour lines give the drawing volume, shape, and depth.

8. **Horizon:** This hand is drawn below your eye-level horizon. You can tell by the foreshortening; it is drawn so that you are looking down at it.

9. **Density:** To further create the illusion of depth, you could draw many hands deeper and farther away in your picture. Drawing these distant hands lighter with less detail would create the illusion of distance.

Now let's start drawing the human hand of creativity!

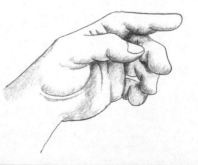

1. Take a look at the drawing at left. Now hold up your left hand in this same position. Looking at your hand, notice how your thumb and fingers are attached to the palm of your hand. Notice how your palm is the shape of an opened foreshortened square. Draw this opened foreshortened square.

2. Take a look at your left hand in the above position again. Notice how your arm slightly tapers to your wrist. Draw this slightly tapered wrist, using size to create depth.

3. Looking at your left hand, see how your thumb bends away from your wrist in two distinct segments. Draw these two segments. Notice how each segment has a slight curve.

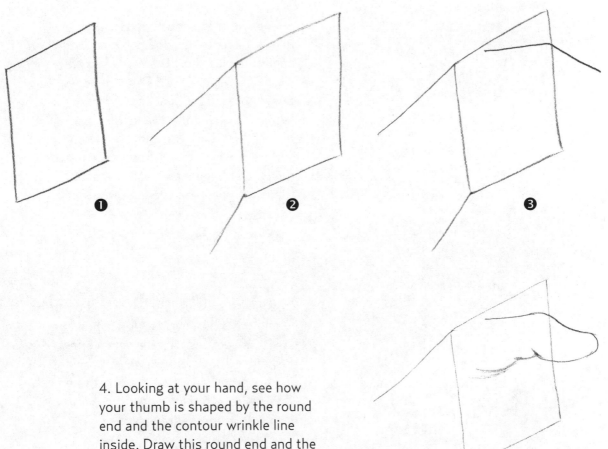

4. Looking at your hand, see how your thumb is shaped by the round end and the contour wrinkle line inside. Draw this round end and the wrinkle contour line.

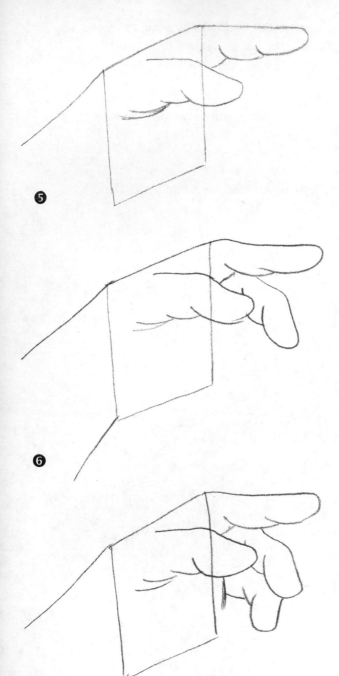

5. Keep looking at your left hand. Are you getting tired of holding it up? You can always take a digital picture with your phone or camera and draw from the screen or from a print. However, it's a really great exercise to draw from the real world of light, shadows, and true depth. Looking at your left hand, notice how your index finger angles away from the palm of your hand. Notice the three sections of your index finger defined by the overlapping contour wrinkles. Draw this index finger with these overlapping curved segments.

6. Looking at your left hand, see how the middle finger bends down in two distinct angles. Look at how the segments are defined by the overlapping wrinkles. I'm hoping this brings to mind our practice of contour lines in Lesson 15. Remember we defined the direction of the tubes with the direction of the surface curves. We are doing exactly the same thing here; fingers are basically small 3-D tubes with defining curving contour lines.

7. Look at how your ring finger is tucked behind the other fingers. Notice how the fingers are getting relatively smaller as they move away from your eye. Draw this ring finger tucked under the other fingers. Define where the ring finger tucks into the palm with an overlapping wrinkle.

8. Look at your little finger. Notice the overlapping, the tapering, the segments, the wrinkled contour lines defining each segment. Now, draw the little finger.

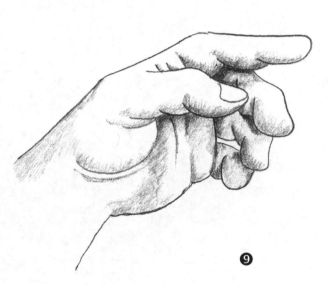

9. For this step, take a very close, careful look at your left hand. Take some time to really see how the room light hits the top of your hand, causing the shading to blend up from the bottom. Notice the dark nook and cranny shadows between each finger and how these shadows really define the edges of each finger. Look at how the wrinkles on the palm wrap around your hand to give it shape and volume. Now, from these observations and with application of the Nine Fundamental Laws of Drawing, complete this sketch of your hand.

Lesson 30: Bonus Challenge

In your sketchbook, practice drawing your hand in three different positions. To inspire you, take a look at these student sketches of three hands. This is a perfect visual icon to bring our thirty-lesson journey to an end. Your hand of creativity! Your hand, your imagination, your sketchbook . . . enjoy your continuing expedition into this inspired world of drawing in 3-D!

Student samples

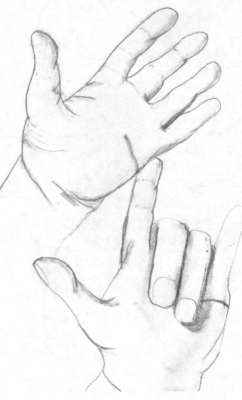

By Ann Nelson

By Michele Proos

I want to thank you for sharing this time with me during these thirty lessons. What an accomplishment you have achieved! For three years, writing this book was an intense labor of creativity. At times thrilling, at times (during the 17th edit phase) similar to a root canal procedure, but as my friend McNair Wilson (www.mcnairwilson.com) says, "It's supposed to be hard. IT'S ART!"

I trust you have found this journey to be as rewarding as I have. Please take a few minutes to e-mail me at www.markkistler.com, and let me know your thoughts and experiences with this book. Please e-mail me scans of some of your favorite drawings (300 DPI or less). I look forward to seeing your creative work!

This is just the beginning of an amazing life-enriching journey of creative discovery and visual expression! I am honored that you chose to ignite your passion for drawing with me. Keep drawing every day, twenty or thirty minutes; doing so will continue to nourish your heart, mind, and soul.

Dream it! Draw it! Do it!

Mark Kistler
Houston, Texas

Please use the following pages to practice your drawing lessons.

✳✳✳

Lesson: _____ Date: _____